MANGAMANIA ™
Shonen

**drawing
action-style
Japanese
comics**

Chris
Hart
Books

Chris Hart Books

An imprint of
Sixth&Spring Books
233 Spring St.
New York, NY 10013

Editorial Director
ELAINE SILVERSTEIN

Book Division Manager
WENDY WILLIAMS

Senior Editor
MICHELLE BREDESON

Copy Editor
KRISTINA SIGLER

Art Director
DIANE LAMPHRON

Associate Art Director
SHEENA T. PAUL

Book Design
DAVID R. WOLF

Contributing Artists
JENNYSON ROSERO
NAO YAZAWA
KRISS SISON
ROBERTA PARES
AURORA TEJADO
DIANA DEVORA
JOSÉ CARLOS SILVA
JIM JIMENEZ

Color
ROMULO FAJARDO

Vice President, Publisher
TRISHA MALCOLM

Production Manager
DAVID JOINNIDES

Creative Director
JOE VIOR

President
ART JOINNIDES

Library of Congress Control Number: 2008925015

ISBN-13: 978-1-933027-69-2

ISBN-10: 1-933027-69-X

Manufactured in China

3 5 7 9 10 8 6 4 2

First Edition

chrishartbooks.com

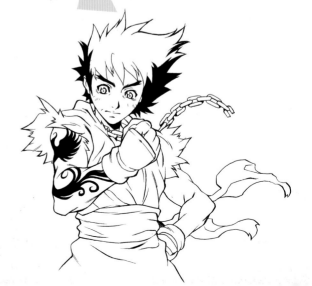

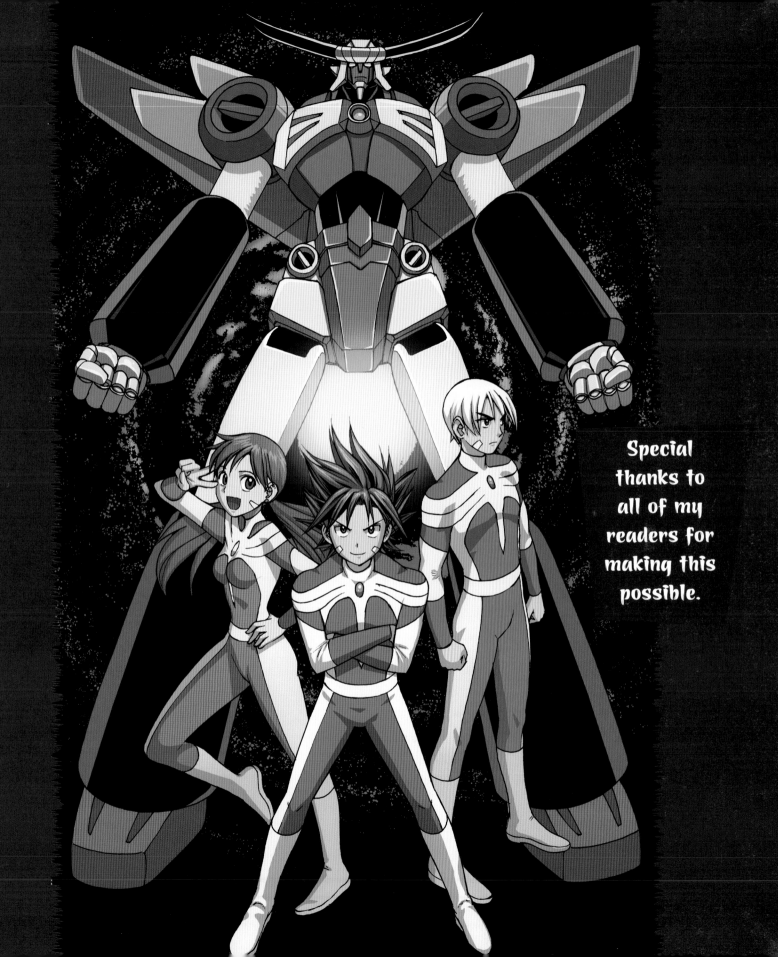

Special thanks to all of my readers for making this possible.

Contents

132

102

55

70

14

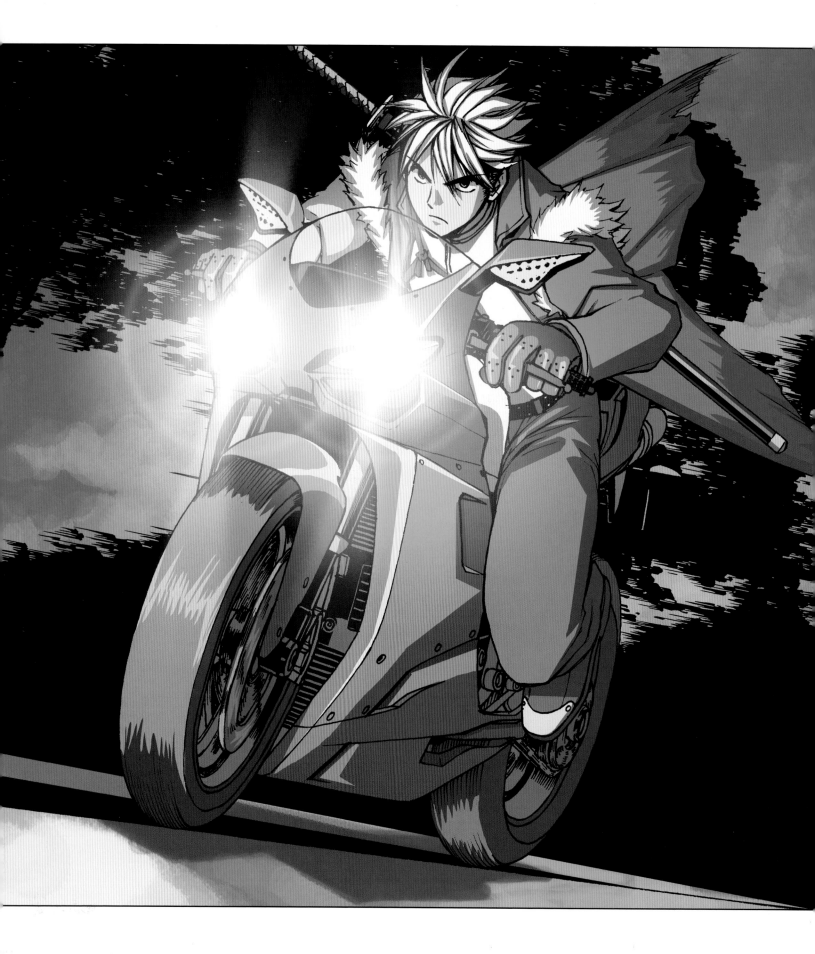

Welcome to the most exciting, pulse-pounding style of manga on the planet.

Shonen (pronounced "shown-in") is the action style of manga, made famous on TV and in graphic novels by such titles as *Naruto, Fullmetal Alchemist* and *Bleach.* This is the first book in the Manga Mania series that focuses solely on the action styles of Japanese comics. Within these pages are the heroic teens, amazing female fighters, bad-to-the-bone villains, samurai warriors and giant robots that have built the manga section of bookstores into such an enormous size and success. This is the style that's got it all.

Step behind the scenes and see exactly how shonen manga is created. First, tackle the basics of drawing the head and body proportions. Next, discover the correct way to draw action that pops off the page. Then, leap forward into character design and see how action characters come to life in their eye-catching costumes. All the most popular and important shonen characters are covered in these pages. You'll learn how to draw them and get tons of ideas for creating your own action-style characters.

There are literally hundreds of drawings in this book to guide you along the way, and the clear, concise text will give you incredible insight into drawing this exciting style, including how to develop a character's personality. If there's anything you want to know about drawing shonen-style manga, you'll find it here.

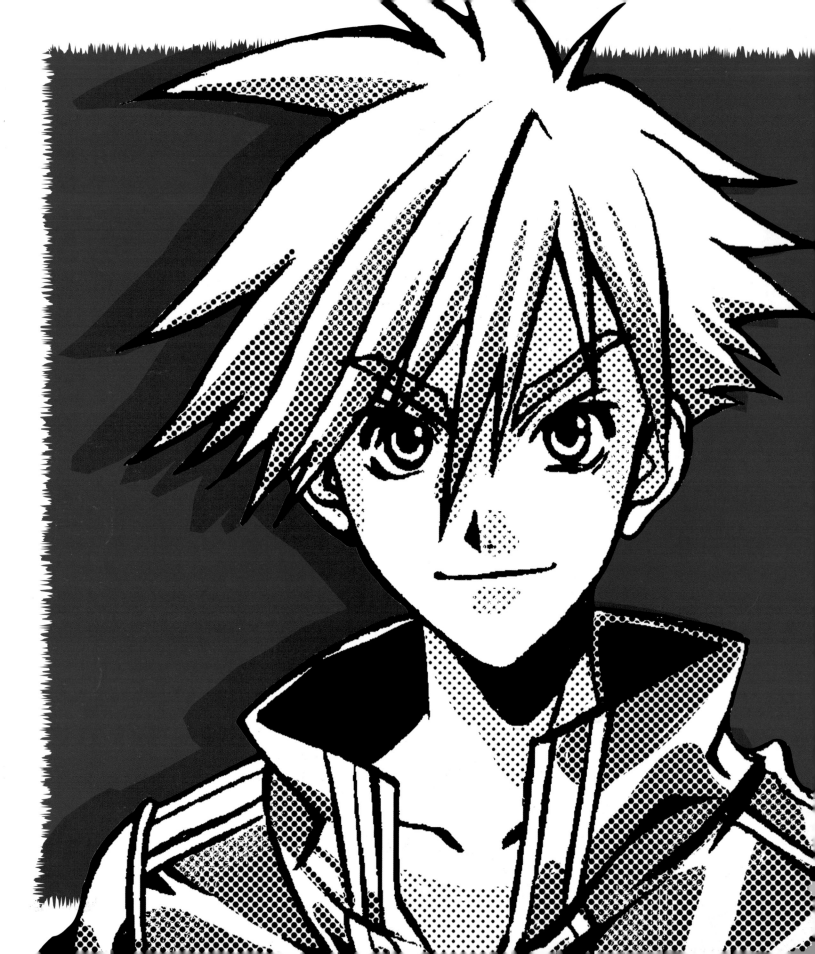

Shonen Basics: Drawing the Head

before we rush headlong into designing cool action characters, we need to take a step back and look at the basics of the shonen style. In this chapter, we'll draw, step by step, the heads of the most popular shonen characters, including the good guys we like to root for and the not-so-nice characters we love to hate. We'll also learn how to draw eyes that express the excitement and urgency of this action-packed style.

Action Boy

This young hero is a star of shonen manga. He fights every type of bad guy, and even monsters. He is often surprisingly young for a character with so much riding on his victory, but making him look slightly underpowered is a surefire way to get the readers' attention, because it leads them to ask, "How in the world is he going to survive the match?!" But of course he will. He'll get knocked down a few times, then gather all the strength he can muster and attack with blinding fury.

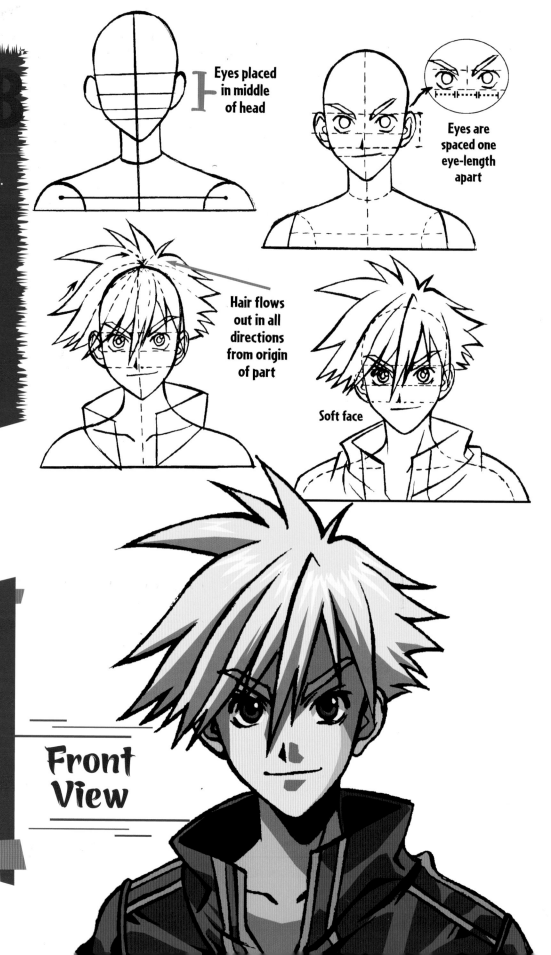

Eyes placed in middle of head

Eyes are spaced one eye-length apart

Hair flows out in all directions from origin of part

Soft face

From Rough Sketch to Finished Art

Throughout this book, you'll see several different styles of artwork: rough pencils, final pencils, inks, gray tones and color art. Generally, a manga artist first blocks out a scene in pencil, then refines it to create a final pencil drawing. The inking is done by hand, right over the pencil lines. Most manga graphic novels are printed in gray tones, which can be created on a computer or shaded by hand. Anime (animated manga) is usually in color.

Front View

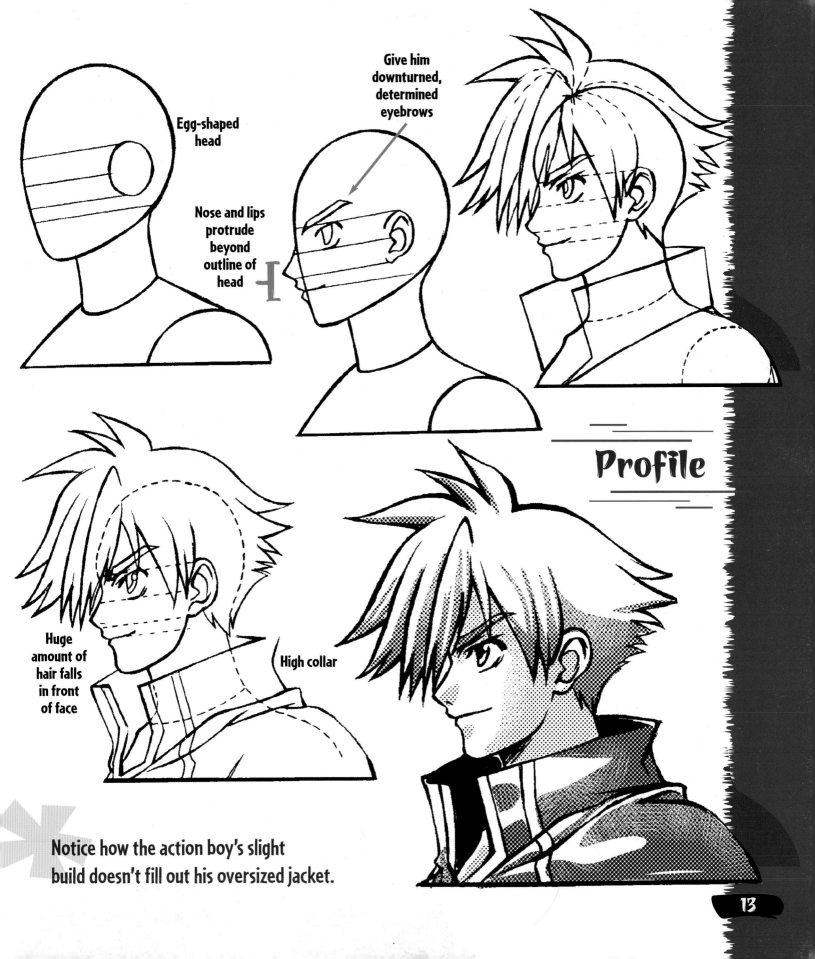

Egg-shaped head

Give him downturned, determined eyebrows

Nose and lips protrude beyond outline of head

Profile

Huge amount of hair falls in front of face

High collar

Notice how the action boy's slight build doesn't fill out his oversized jacket.

13

Teen Enemy

Teen Enemy

He's somewhat older and more mature than the action boy. His face is longer and thinner, with a chin that comes to a point. His eyes are not as round and are more of an almond shape—a sign of evil. And he wears that scar on his face like a badge of honor. Of course you can't trust his smile, but you have to admit he's got a roguish charisma.

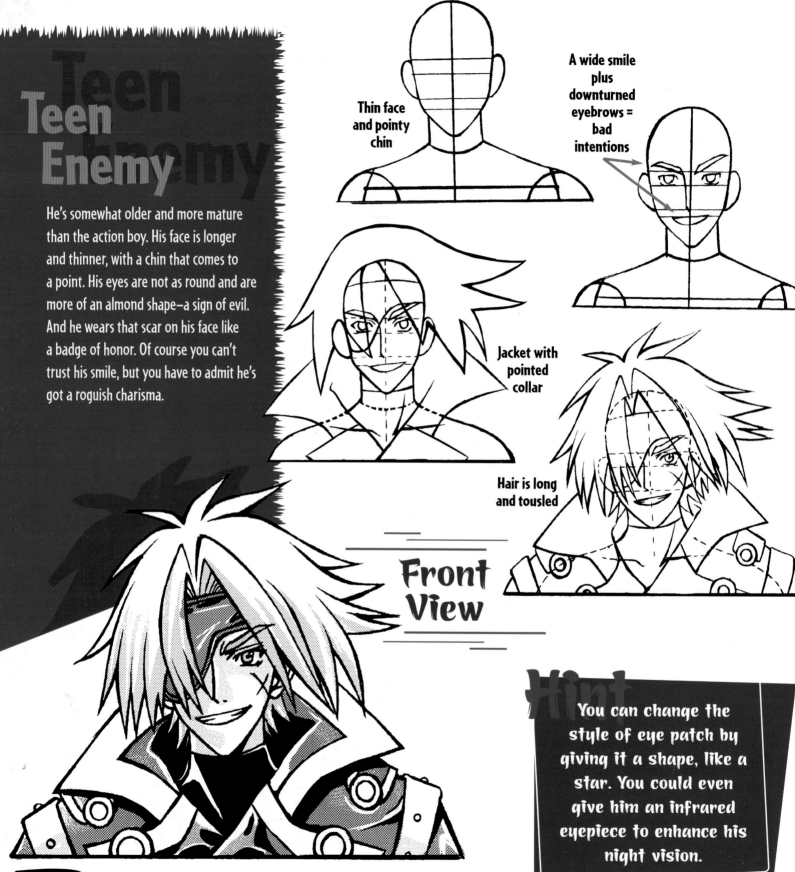

Thin face and pointy chin

A wide smile plus downturned eyebrows = bad intentions

Jacket with pointed collar

Hair is long and tousled

Front View

Hint

You can change the style of eye patch by giving it a shape, like a star. You could even give him an infrared eyepiece to enhance his night vision.

14

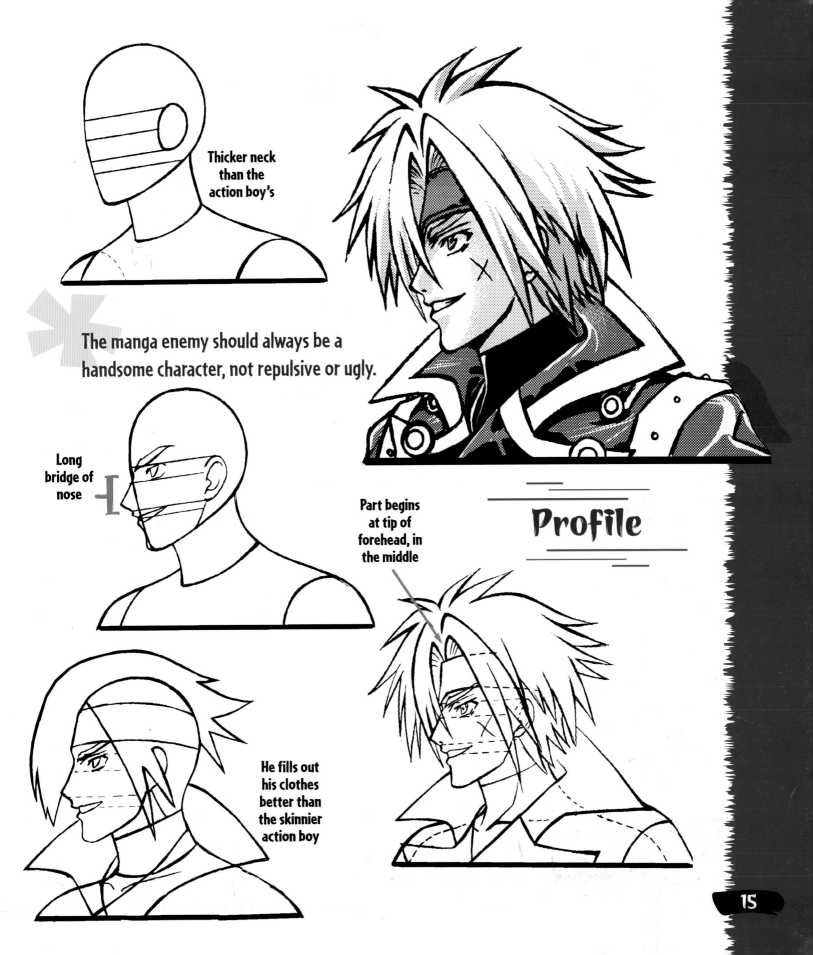

Thicker neck than the action boy's

The manga enemy should always be a handsome character, not repulsive or ugly.

Long bridge of nose

Part begins at tip of forehead, in the middle

Profile

He fills out his clothes better than the skinnier action boy

Girl With Crush

She's got it bad for the action boy, and she *HATES* the dark beauty (see page 18), who flirts with him. She believes in our young hero and encourages him when his spirits start to flag. Her eyes are big and bright—a sure sign of an earnest and true character. She's also an emotional character who has a tough time hiding her feelings. They spill over when she has an emotional outburst or reveals too much of her secret love. But that's all part of her youthful charm.

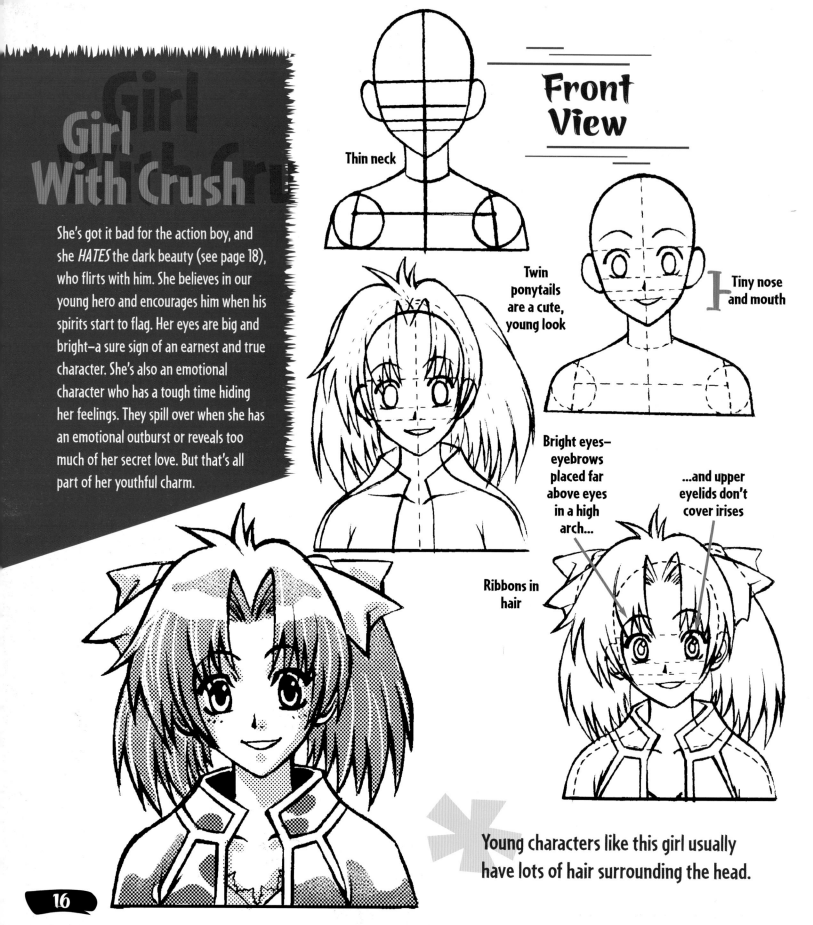

Thin neck

Front View

Twin ponytails are a cute, young look

Tiny nose and mouth

Bright eyes— eyebrows placed far above eyes in a high arch...

...and upper eyelids don't cover irises

Ribbons in hair

Young characters like this girl usually have lots of hair surrounding the head.

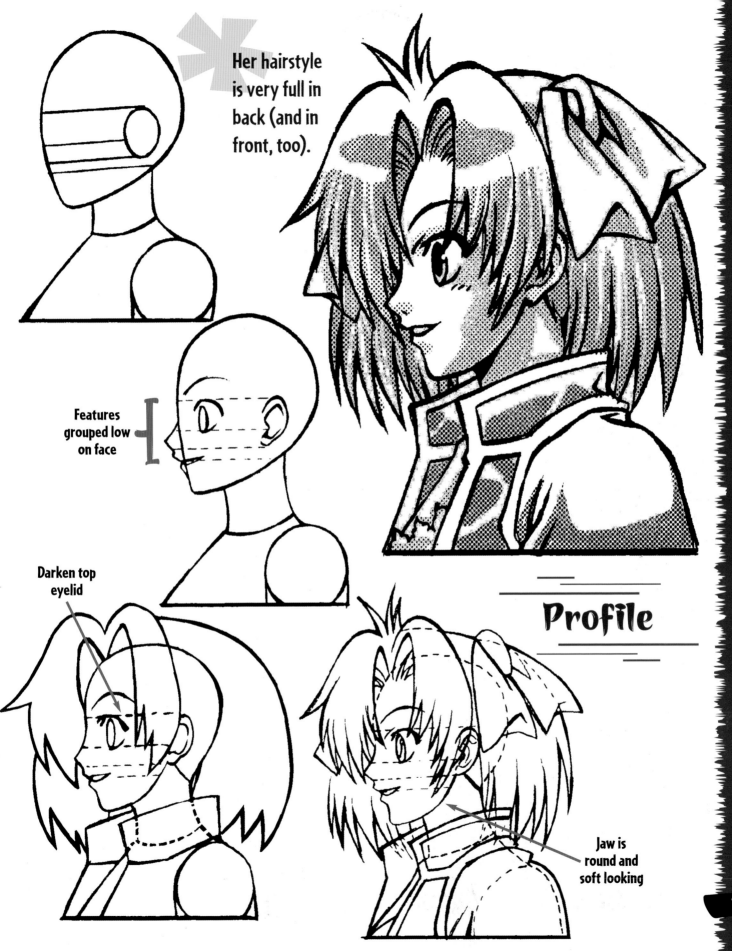

Her hairstyle is very full in back (and in front, too).

Features grouped low on face

Darken top eyelid

Profile

Jaw is round and soft looking

Dark Beauty

Evil is glamorous in shonen manga. And nowhere is it as glamorous as on the dark beauty. There's always the danger that the good guy will be seduced by her charms. She is a totally untrustworthy character, a deceiver and a manipulator. But she's so good at it that she's irresistible to watch.

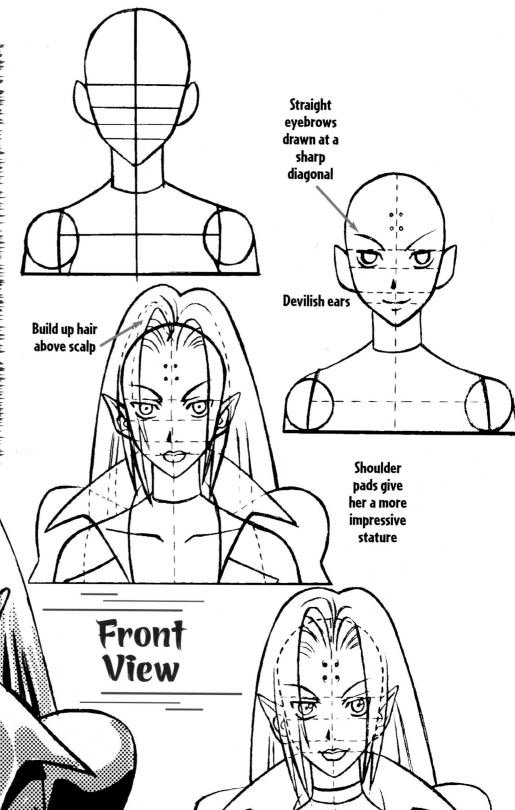

Straight eyebrows drawn at a sharp diagonal

Devilish ears

Build up hair above scalp

Shoulder pads give her a more impressive stature

Front View

18

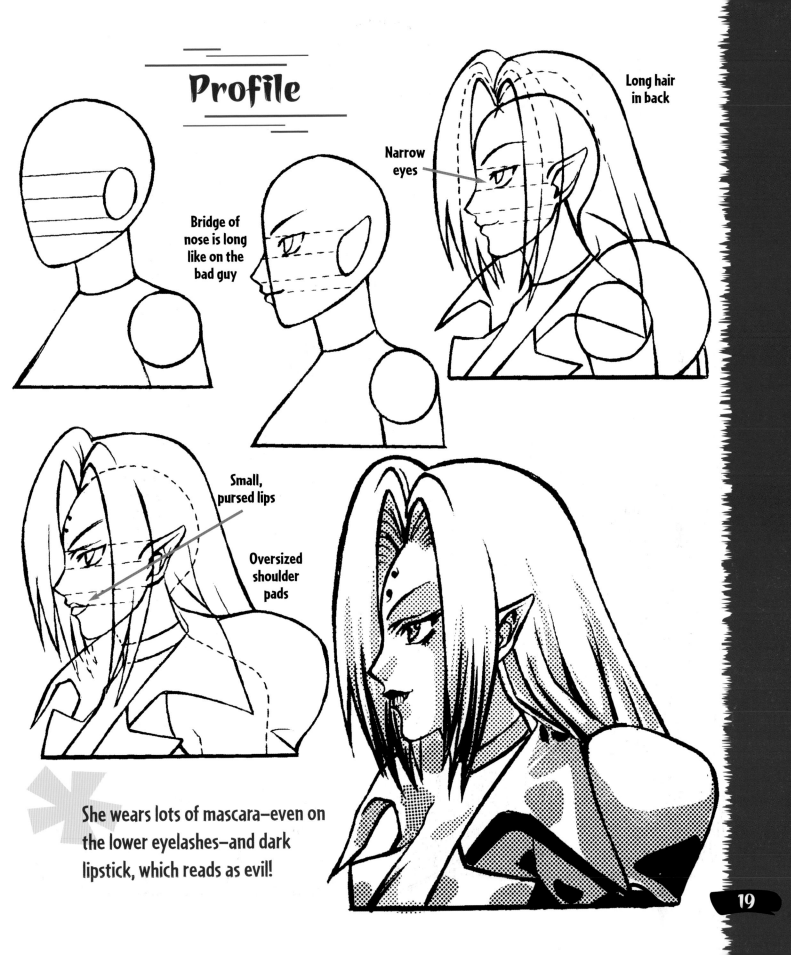

Profile

Long hair in back

Narrow eyes

Bridge of nose is long like on the bad guy

Small, pursed lips

Oversized shoulder pads

She wears lots of mascara—even on the lower eyelashes—and dark lipstick, which reads as evil!

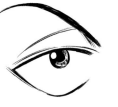
Heroic

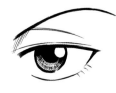
Sincere

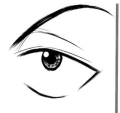
Bored

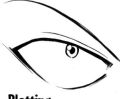

Plotting

Drawing Eyes for Action Characters

How do you get good at drawing eyes? By drawing eyes! And this section provides lots of examples to give you plenty of practice. We'll focus on the most popular characters in the shonen style: teens and adult villains.

Be sure to vary the thickness of your line. Upper eyelids are always darker than lower eyelids. Remember to get the eyebrows into the act, too!

Scared

Young Teen Boy

This very popular character type ranges in age from about 12 to 15. He's usually portrayed as earnest, sincere and fiercely determined. But he lacks guile and is vulnerable to the double-dealing ways of villains. His pupils are normally large and round—a sign of honesty. But even he can have a bad thought flash across his eyes, which will result in beady pupils.

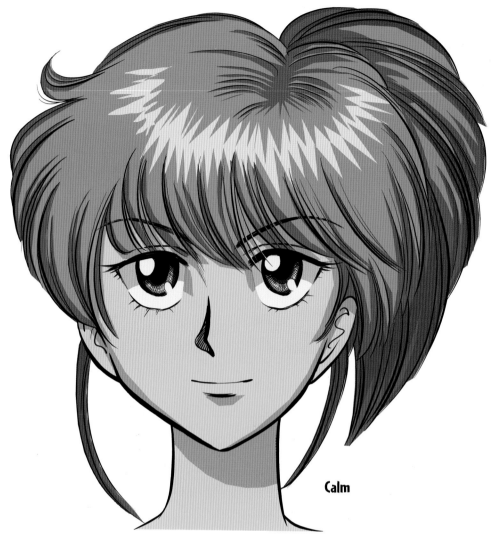

Calm

Young Teen Girl

When you draw girls' eyes, think of dark eyelids and thick eyelashes that flare up at the ends. That's where the emphasis needs to be.

These Eyes Are True Blue

In shonen manga the girl co-star is the one who believes in the hero. She may have a secret crush on him, or just be his loyal friend. But when treachery is around every corner, it's good to have someone like her on your side!

This character is often used to give the reader an "emotional cue." What do I mean by that? Here's an example: Suppose a powerful bad guy challenges our teen boy to a fight. When he naturally accepts, the girl freaks out. Why? Because she knows that the boy can't win—the enemy is too powerful. She begs him not to go ahead with the fight. The girl is giving the reader a cue that the fight is going to be extremely dangerous for our young hero. In this way, she helps build anticipation and heighten suspense. (But the boy may surprise her yet!)

Scared Caring

Upset Embarrassed

21

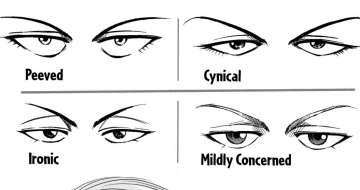

Peeved

Cynical

Ironic

Mildly Concerned

Bishojo Girl

Bishojo (pronounced "bee-show-joe") is the counterpart to the male bishie and means "pretty girl" in Japanese comics. She's a mature teen or young adult—never a young girl. Her eyes are almond shaped (sleeker and narrower than the young teen girl's), with glamorous long lashes and darkened upper eyelids.

The famous "eye-shine" overlaps both the pupil and the iris.

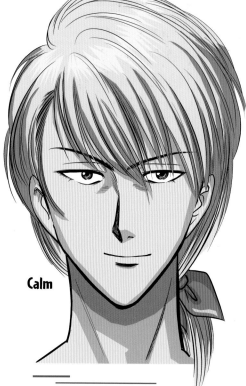

Calm

Hint

The bishie's elegant eyebrows angle downward, but be sure to give them just a slight downward turn, or you'll risk making him look angry. Instead, the thin eyebrows should make him look like a cynic.

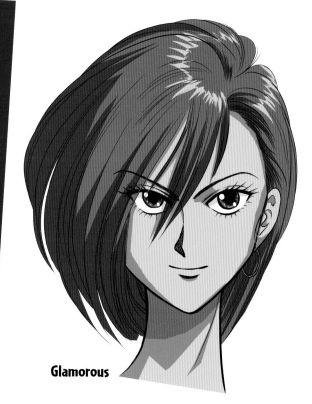

Glamorous

Bishie Boy

As the teen boy ages, he becomes more mysterious and brooding. His eyes are narrow and lack the roundness of younger fighters' eyes. That's because he doesn't need to look so earnest and pure. He's streetwise.

This type of character is known as a *bishie* (pronounced "bee-shee")–a charismatic male character in Japanese comics. Bishies also appear in the shojo style as well as the occult, samurai and historical genres. In shonen manga, they're usually depicted as amazing fighters.

Satisfied

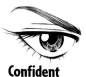

Confident

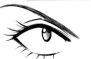

Annoyed

Suspicious

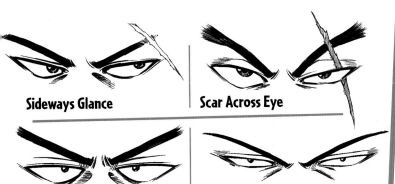

Sideways Glance

Scar Across Eye

Slightly Cross-eyed

Squeezed Eyeballs

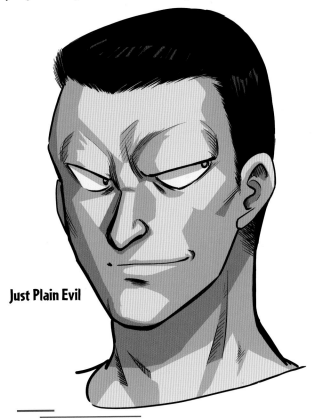

Just Plain Evil

Male Villain

The evil guy gets the beady-eye treatment. Notice how he peers out of the corners of his eyes. This shows that a character is thinking bad thoughts. The eyebrows crush together at the bridge of the nose, creating creases around the eyes. And if you like, you can also add a slashing scar across one eye, making him look even more dangerous.

Female Villain

These are the eyes of a woman with wicked intentions. Classic evil eyes are always drawn in a narrow shape. They also have tiny little irises surrounded by the whites of the eyes. The eyebrows are not only thin, but are drawn in an ultra-high arch. It's an extreme look that is completed by short, sharp bottom eyelashes.

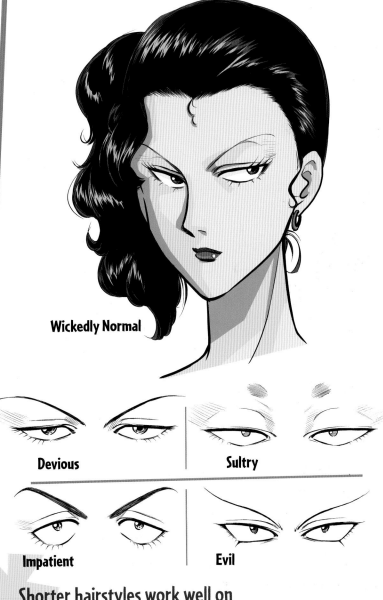

Wickedly Normal

Devious

Sultry

Impatient

Evil

Shorter hairstyles work well on evil female characters.

Craaaazy Eyes!

Part of the fun of drawing evil characters is that you get to invent crazier eye types than when drawing the good guys, who have to look noble and honest. Completely blank eyeballs, pinpoint pupils and eye patches are just a few surefire ways to make a character look creepy or wicked.

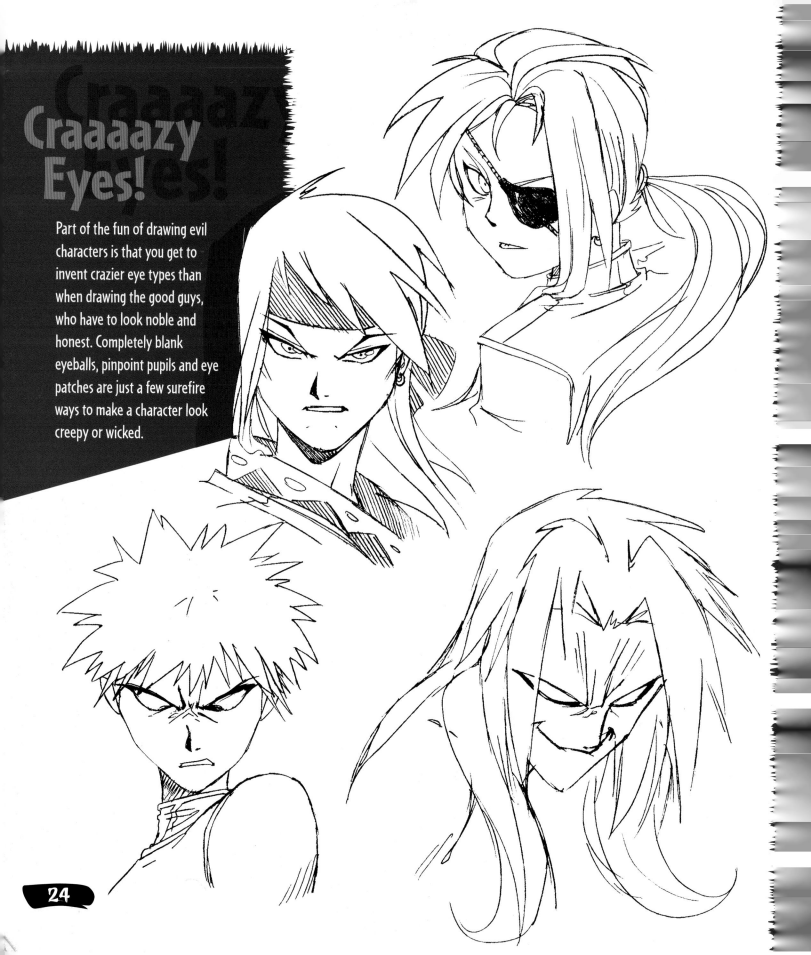

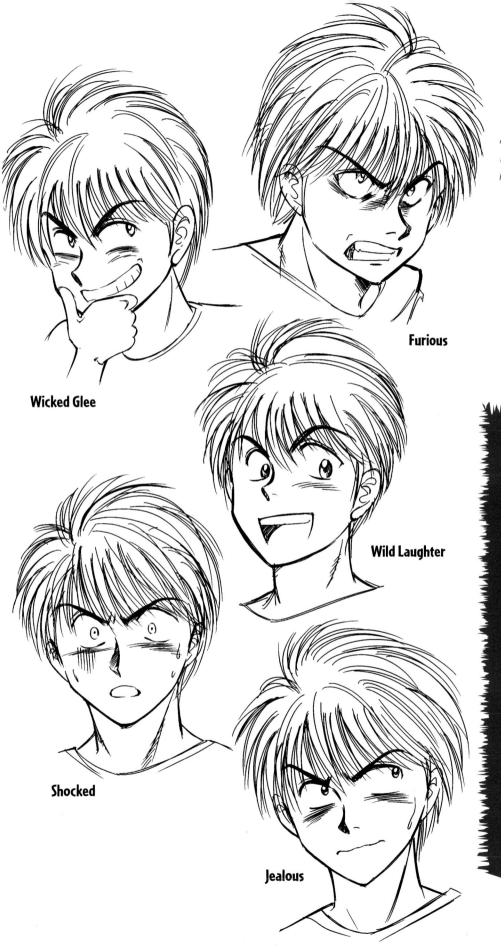

Wicked Glee

Furious

Fed Up

Wild Laughter

Shocked

Jealous

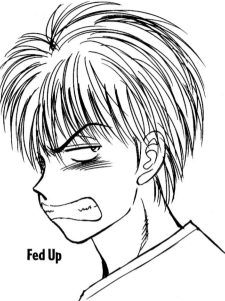

Intense Expressions

Action is intense. There's usually a lot at stake—sometimes even life and death. The characters' expressions need to communicate this intensity to the reader. Use a liberal amount of shading just under the eyes to convey a face that is flushed with anger and emotion. Let the hair get shaggy and wild. And really work those eyebrows so that they push down at the bridge of the nose. Where applicable, grit the teeth—a sign of extreme emotion and distress.

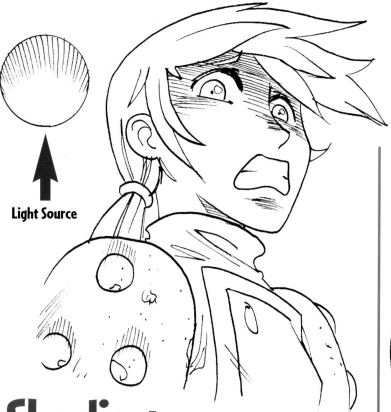

Light Source

Light Source

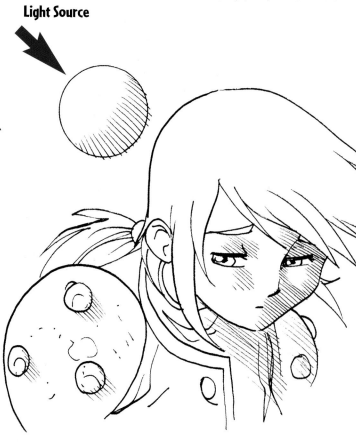

Light Source

Shading Faces

drawn correctly, shadows can add intensity to a drawing and increase the drama of a scene, but most beginning artists end up shading areas that don't make sense—areas that should be hit with light, not shadow. You can't add shading just anywhere. If you don't have an understanding of the principles of shading, you could end up making the face look dirty, not shadowy. Just remember: When light falls on an object from one direction, a shadow appears on the *opposite* side of the object.

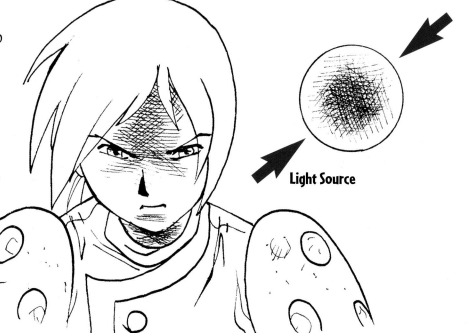

Light Source

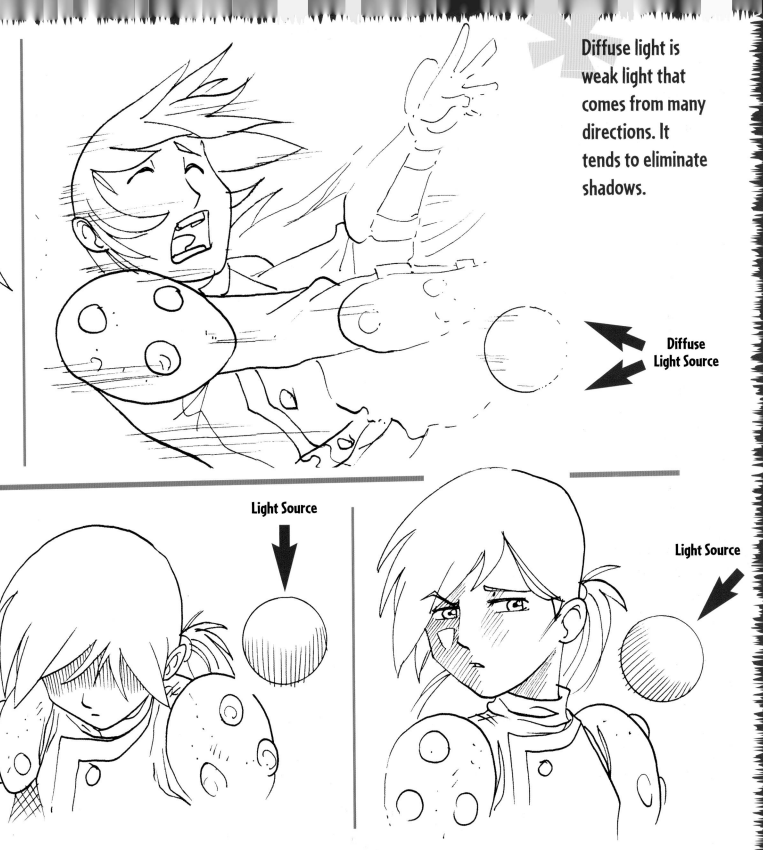

Diffuse light is weak light that comes from many directions. It tends to eliminate shadows.

Diffuse Light Source

Light Source

Light Source

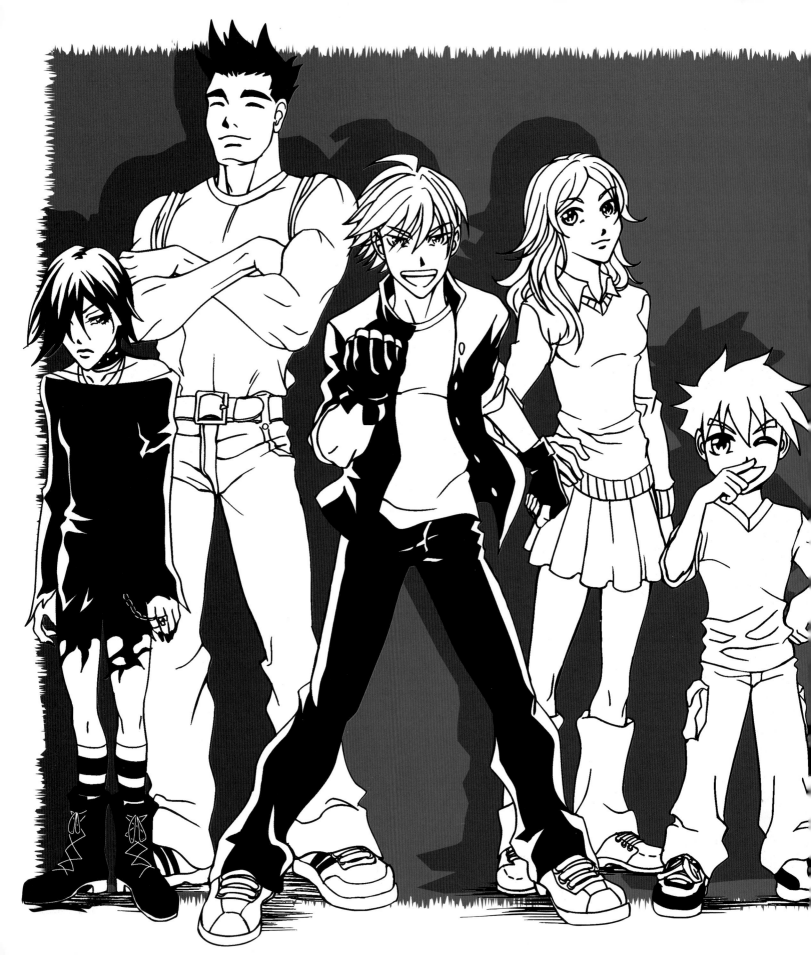

Shonen Basics: Drawing the Body

now that you have a handle on drawing the heads of classic shonen characters, it's time to tackle the bodies. While it may seem more challenging, we'll take it step by step and throw in lots of tricks—like measuring a character's height in "heads"—to make it easy. Finally we'll look at the characters side by side and team them up so you'll be well on your way to creating a cast of dynamic action characters.

Body is 2 "heads" across: ½ per shoulder and 1 for the head

Body slightly stocky–he's no pushover

The boy hero is 7¼ heads tall.

Hint

An easy way to build the correct proportions of the body is to start with an equilateral triangle and then superimpose a square onto it.

Rough-and-tumble fighting clothes

Brave Fighter Kid

Brave
Fighter Kid

The fighter kid has a medium build. He's not overly muscular, but he's not skinny either. He's completely average—and that's the point of manga. Instead of superpowered heroes, regular guys and gals save the day. They're ordinary people doing extraordinary things, making it easy for us to relate to them. In manga, *we're* the heroes. And we don't need capes or superpowers, just guts and a fighting spirit.

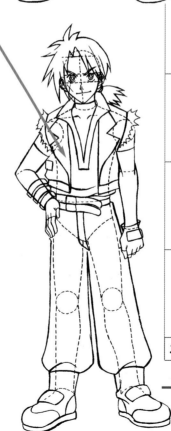

1

2

3

4

5

6

7

7 1/4

Front View

Heads Up!

The method artists use to measure a character's height is to count heads. Simply measure the size of the head and count how many "heads" tall the figure is. Drawing horizontal lines behind the figure, as shown on these pages, makes it easy to do the math.

Normal people measure about 6 heads tall, but our fighter boy is over 7 heads tall! Older teens and characters in their twenties can be taller still. And note that except for kids and young teens, most shonen characters are drawn with relatively small heads, compared to their bodies. It's the thing that differentiates shonen characters from shojo characters, who have big heads and huge eyes.

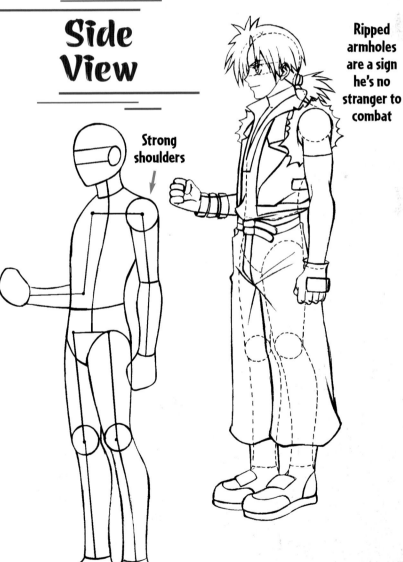

1

2

3

4

5

6

7

7 1/4

Side View

Strong shoulders

Ripped armholes are a sign he's no stranger to combat

Straps, gloves, boots and loose clothes for punching and kicking— he's ready to fight!

Powerful Foe

Bad guys are almost always older and more mature physically than the young hero. The villain should look significantly more powerful than our good guy, too. Notice the bad guy's arms and shoulders—they're rock solid and popping with muscles, making him look broad. He's also considerably taller. This should intimidate the young hero, but of course it won't!

*The bad guy is 8¾ heads tall.

Front View

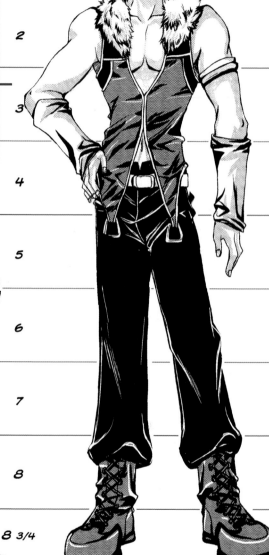

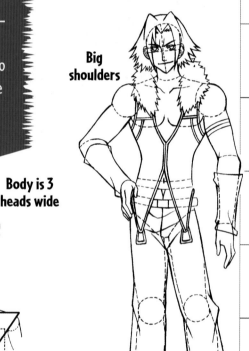

Body is 3 heads wide

Thin waist accentuates size of chest

Big shoulders

Long legs

Hint

Give the villain body-builder-style shoulders and arms, but keep the rest of him skinny to create an overall lanky appearance.

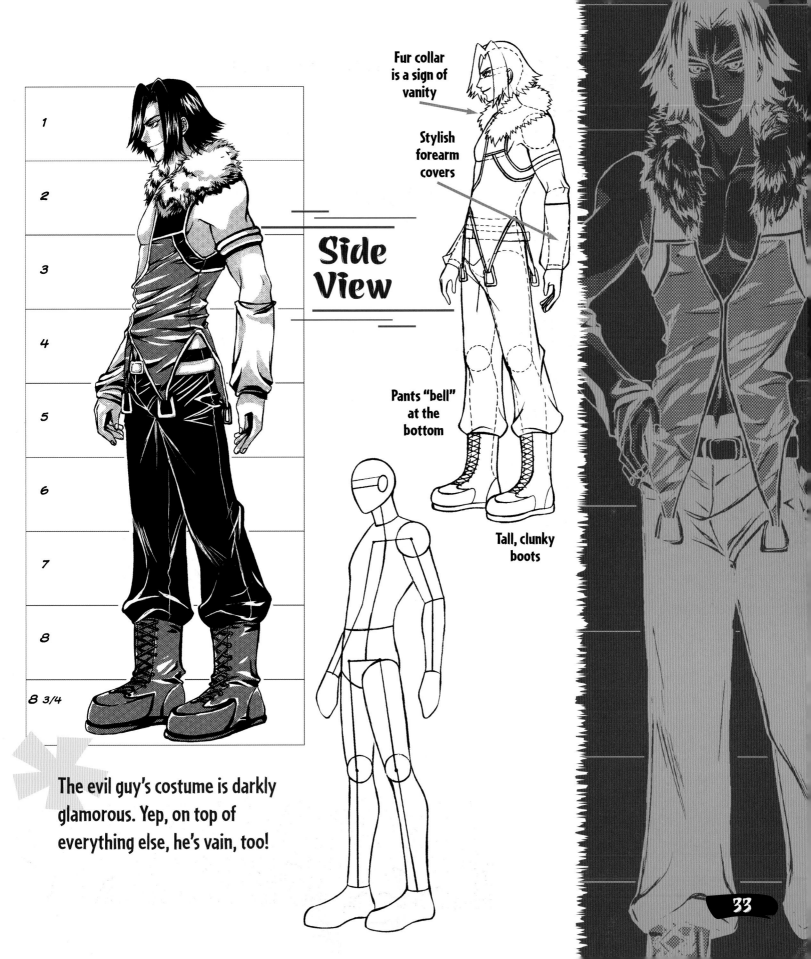

1

2

3

4

5

6

7

8

8 3/4

Side View

Fur collar is a sign of vanity

Stylish forearm covers

Pants "bell" at the bottom

Tall, clunky boots

The evil guy's costume is darkly glamorous. Yep, on top of everything else, he's vain, too!

The Hero's Girl

The Hero's Girl

If there's one character who's a holdover from the shojo style, this girl is it. She's a perky character who wears her heart on her sleeve. You always know where she stands on any matter, because she lets you know in no uncertain terms. Think of her as the girl next door. Sometimes she's so annoyingly good, kind and loyal that you almost wish the bad guys would finish her off so our hero could date the bad girl! The good girl has a feminine yet athletic figure and wears pretty clothes.

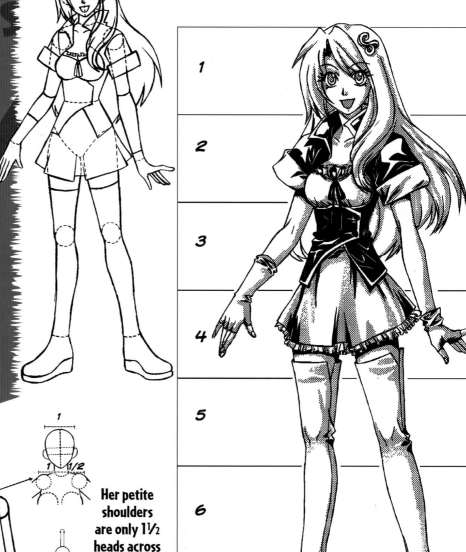

1
2
3
4
5
6
7

Her petite shoulders are only 1½ heads across

Torso narrows in the middle, like a violin

Front View

Hint

Tall boots or leggings combined with a short skirt is a popular look for teen girls in manga.

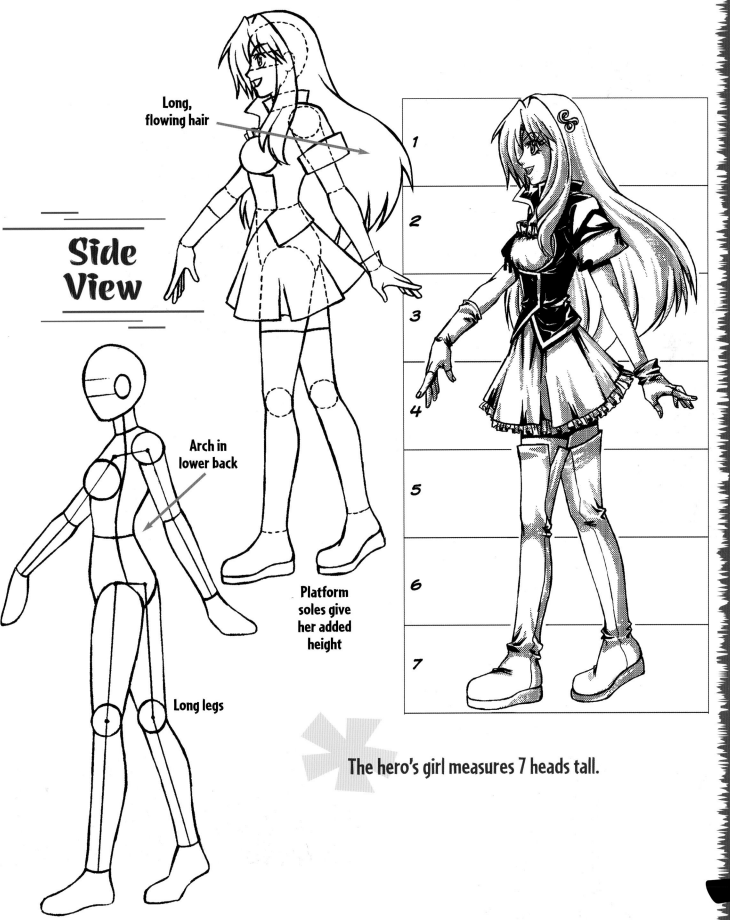

Long, flowing hair

Side View

Arch in lower back

Long legs

Platform soles give her added height

1

2

3

4

5

6

7

The hero's girl measures 7 heads tall.

Alluring Nemesis

This evil beauty usually teams up with her male counterpart, and they use their combined powers to try to destroy the fighter boy. But while she may have special powers, she's also a master deceiver who can convince the hero she's on his side. This shady lady is always drawn as a stylish, sexy character. She wears a dark outfit with many highlights that give the clothing a shiny look.

Hint

To create a sexy hourglass shape, give her a wide rib cage, narrow waist and wide hips.

Shoulders are 1½ heads wide

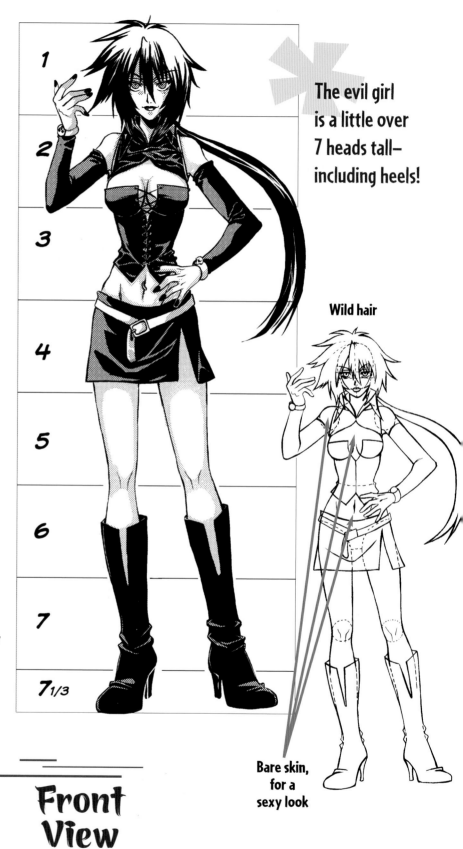

The evil girl is a little over 7 heads tall— including heels!

Wild hair

Extremely long, shapely legs

Bare skin, for a sexy look

1

2

3

4

5

6

7

7 1/3

Front View

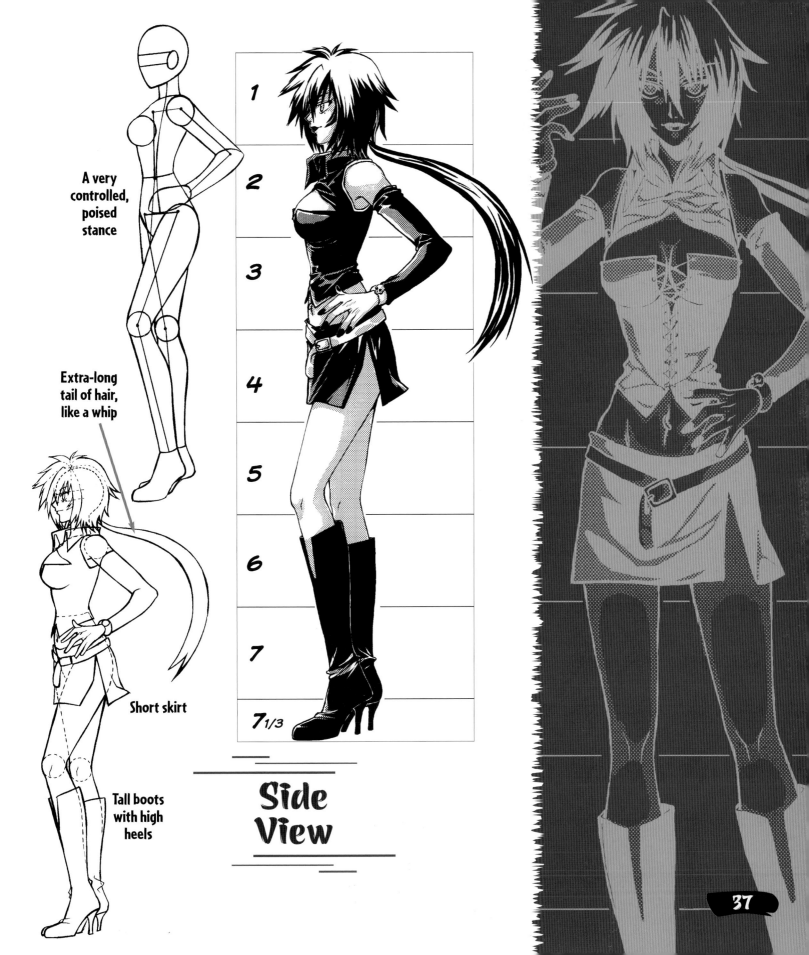

A very controlled, poised stance

Extra-long tail of hair, like a whip

Short skirt

Tall boots with high heels

1
2
3
4
5
6
7
7 1/3

Side View

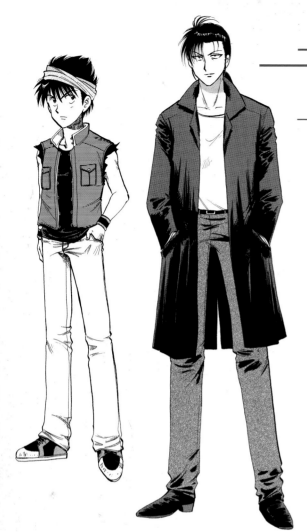

Male

The young teen is 12 to 14 years old, and the older teen is anywhere from 15 to 19 years, or sometimes even in his early twenties. Even though they are quite different in appearance, they are often featured in the same story and fight on the same side. It's almost like a big brother-little brother relationship, except that the younger character can handle himself every bit as well as the older character, due to his expert fighting abilities and indomitable spirit.

Hint

An older character's head is smaller relative to his body than a younger teen's. Always use a big head-to-body ratio to signify youth.

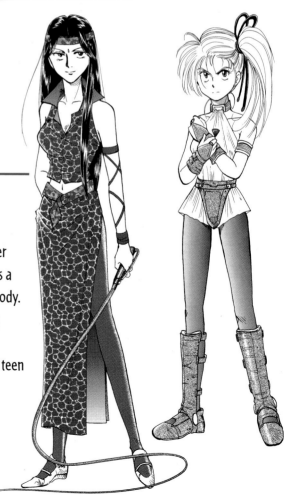

Female

Besides being taller, the older female character has a curvier, more mature build. The younger girl is a bit of a tomboy and has a smaller, more compact upper body. Both, however, have extra-long legs. The younger girl sports a fighter's outfit, while the older teen gal wears a sexy, exotic dress.

Younger Vs. Older Teens

Now let's put older and younger teens side by side, for comparison's sake. Until you see them next to each other in full-length poses, you may not realize just how different they are.

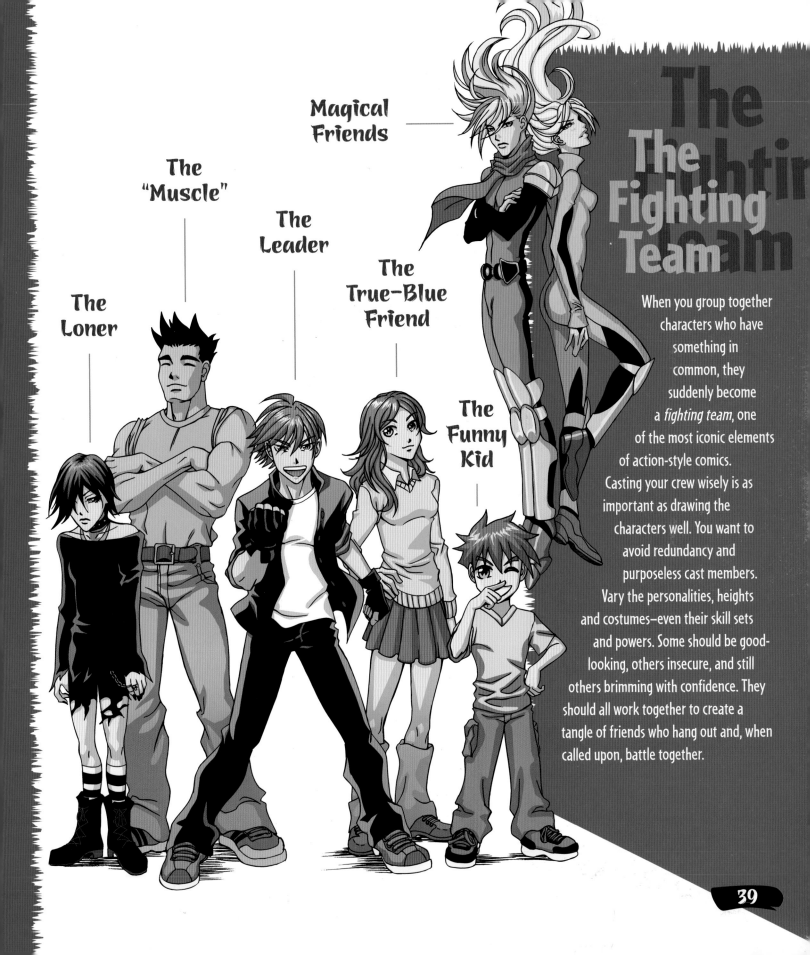

Magical
Friends

The
"Muscle"

The
Leader

The
True-Blue
Friend

The
Loner

The
Funny
Kid

The Fighting Team

When you group together characters who have something in common, they suddenly become a *fighting team*, one of the most iconic elements of action-style comics. Casting your crew wisely is as important as drawing the characters well. You want to avoid redundancy and purposeless cast members. Vary the personalities, heights and costumes—even their skill sets and powers. Some should be good-looking, others insecure, and still others brimming with confidence. They should all work together to create a tangle of friends who hang out and, when called upon, battle together.

The Character Lineup

The Character Lineup

When drawing new characters, we think very hard about how they look but often pay little attention to their height. However, height is an important element in creating a character design. For example, a short hero needs to show more guts, because he's at a height disadvantage. A tall villain is more self-confident. These pages compare the heights of popular shonen characters.

Each horizontal bar drawn behind the characters is approximately 1 head high. You can use this wall of measurements to count how many "heads" each character is. For example, the good girl is about 7 heads tall, while the evil girl is over 8 heads tall. The demon and the *shinigami*, a common figure of death in manga, are much taller than their human costars.

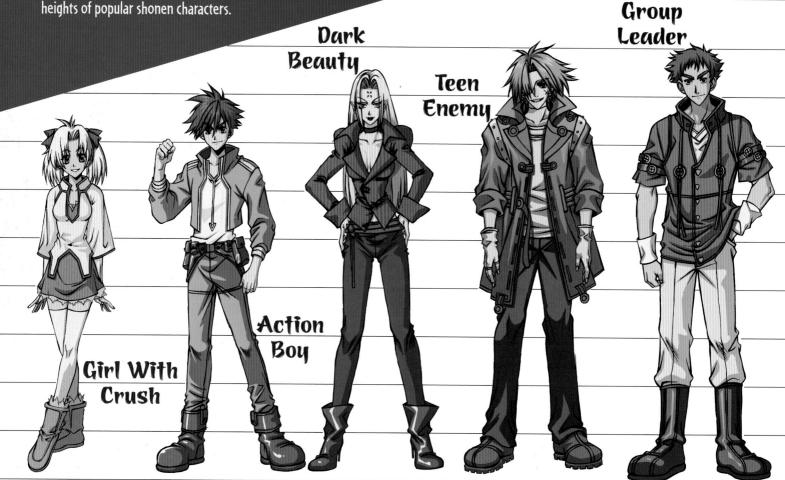

Girl With Crush

Action Boy

Dark Beauty

Teen Enemy

Group Leader

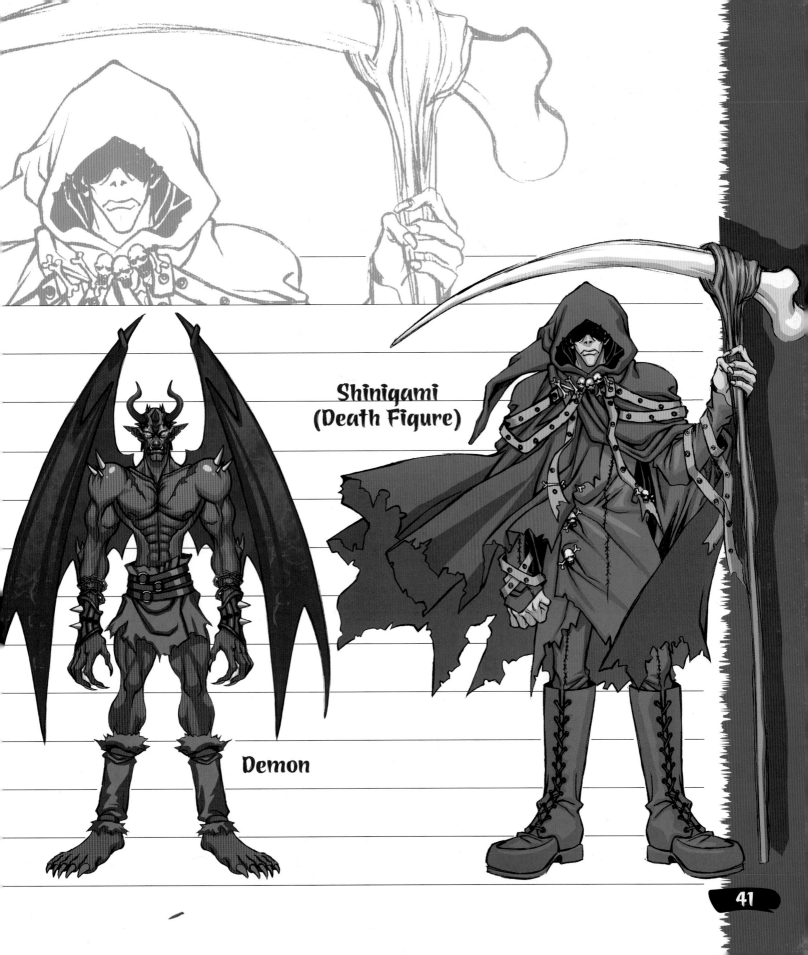

Shinigami
(Death Figure)

Demon

41

Action Tattoos

manga action characters don't always wear flamboyant costumes like those of their counterparts in American comics. So tattoos are often used to jazz up a character and give him or her an edge. Sometimes the tattoo is of a dragon, a predatory bird or a mythical beast. Even an abstract design will do. Words don't work, because they are part of the artwork and won't get translated when the graphic novel is published in other languages.

This guy's arm is decorated with a tattoo of a phoenix, the mythical bird that rises from the ashes.

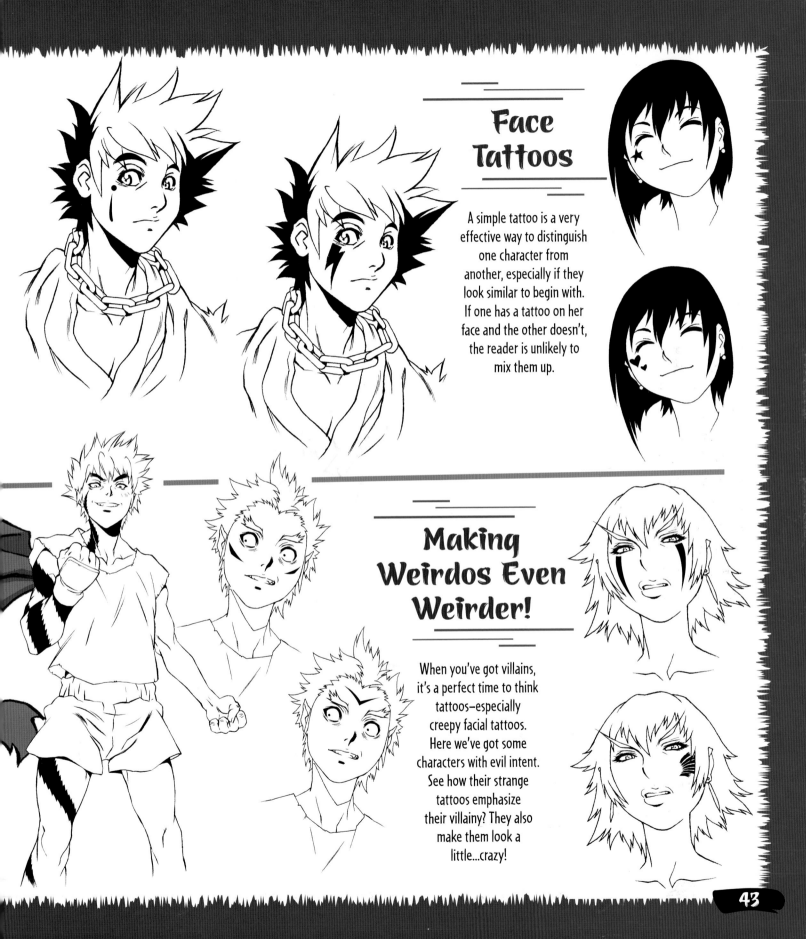

Face Tattoos

A simple tattoo is a very effective way to distinguish one character from another, especially if they look similar to begin with. If one has a tattoo on her face and the other doesn't, the reader is unlikely to mix them up.

Making Weirdos Even Weirder!

When you've got villains, it's a perfect time to think tattoos—especially creepy facial tattoos. Here we've got some characters with evil intent. See how their strange tattoos emphasize their villainy? They also make them look a little...crazy!

Action!

Once you've mastered the basics of drawing action-style characters, what do you do next? That's an easy one. Put them in exciting action scenes! This chapter will show you how to create high-energy scenes that leap off the page.

Running...punching... kicking...lunging... they're all here! You'll also learn to use forced perspective to create intense action poses and discover the secrets for drawing pulse-pounding fight scenes. So grab your pencil and paper and get ready for some action!

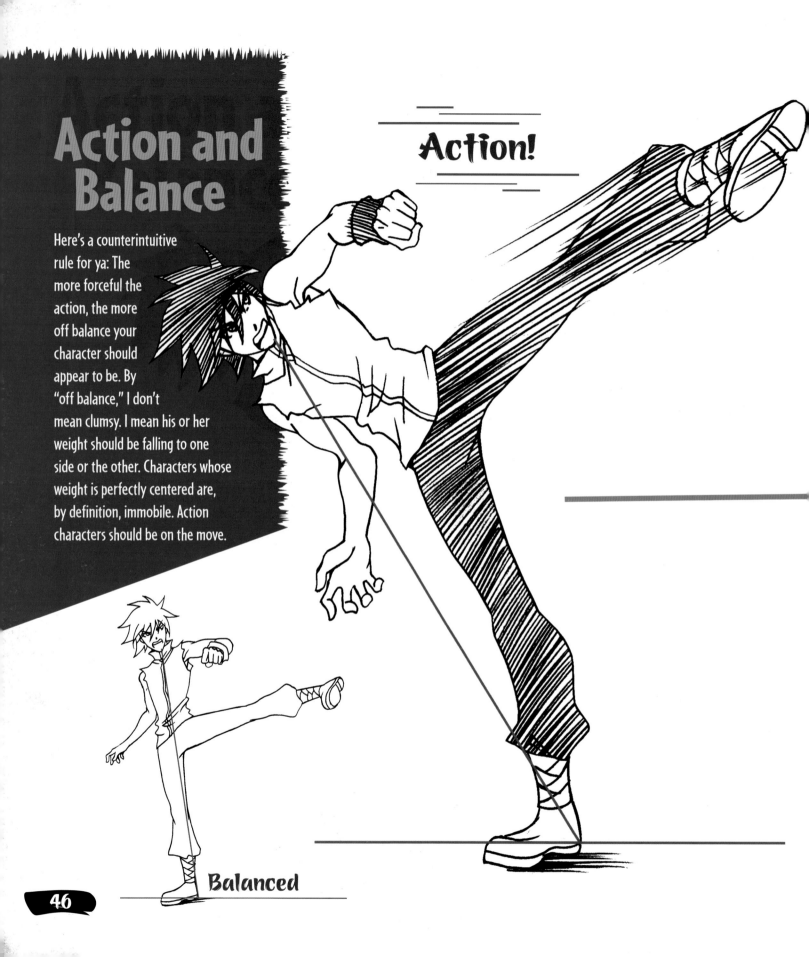

Action and Balance

Here's a counterintuitive rule for ya: The more forceful the action, the more off balance your character should appear to be. By "off balance," I don't mean clumsy. I mean his or her weight should be falling to one side or the other. Characters whose weight is perfectly centered are, by definition, immobile. Action characters should be on the move.

Action!

Balanced

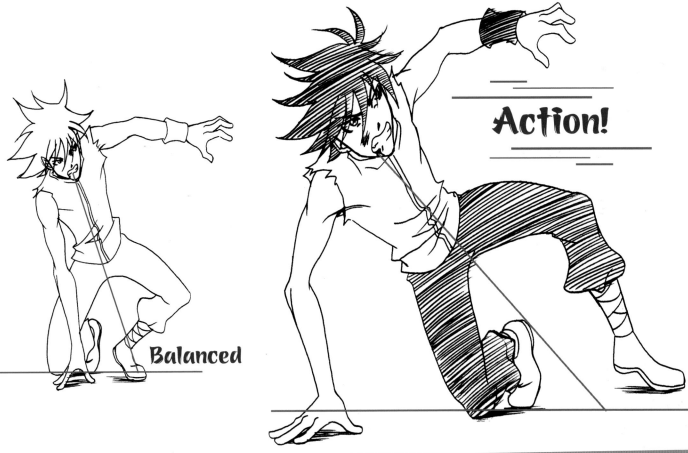

Balanced

Action!

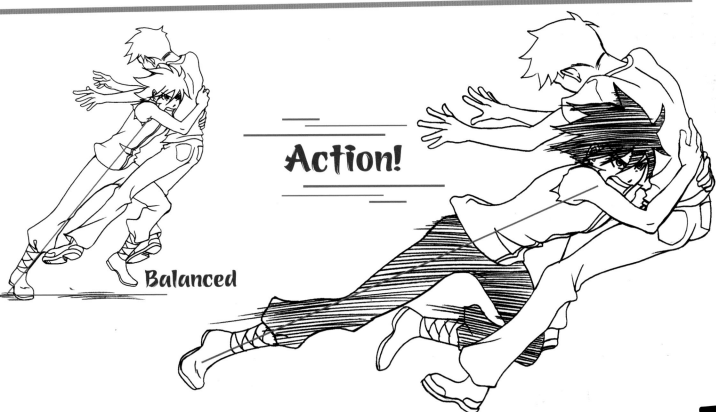

Balanced

Action!

Do's and Don'ts for Drawing Action

We've all done it. We've worked hard to make a drawing of a cool character in an action pose, but still ended up with slightly lower self-esteem than when we started. What went wrong? The figure looks correct, but the pose is stiff, lifeless, frozen. If that's the case, don't be discouraged. It often takes just a few small adjustments to completely reinvigorate the image.

This section will show you the common mistakes artists make in drawing action poses and how you can easily correct them. Those dark days are almost behind you now!

Classic Run: Side View

You've gotta be able to draw an effective run, especially if you've got bad guys in your story–and what's an action story without bad guys? Your hero has to either catch 'em or run from 'em! First and foremost, always show your character leaning into the pose. Never draw him running with his back up straight. Think "diagonals!"

Body leans into run, at a steep diagonal

Weight-bearing "push-off" leg

Do!

Do draw the runner leaning forward, at a diagonal. Tuck the front leg and aim the knee straight ahead. This makes the pose look more streamlined. Do plant the back foot on the ground, so he can push off of it.

Don't

Don't draw both legs coming off the ground at the same time: He'll look like he's floating.

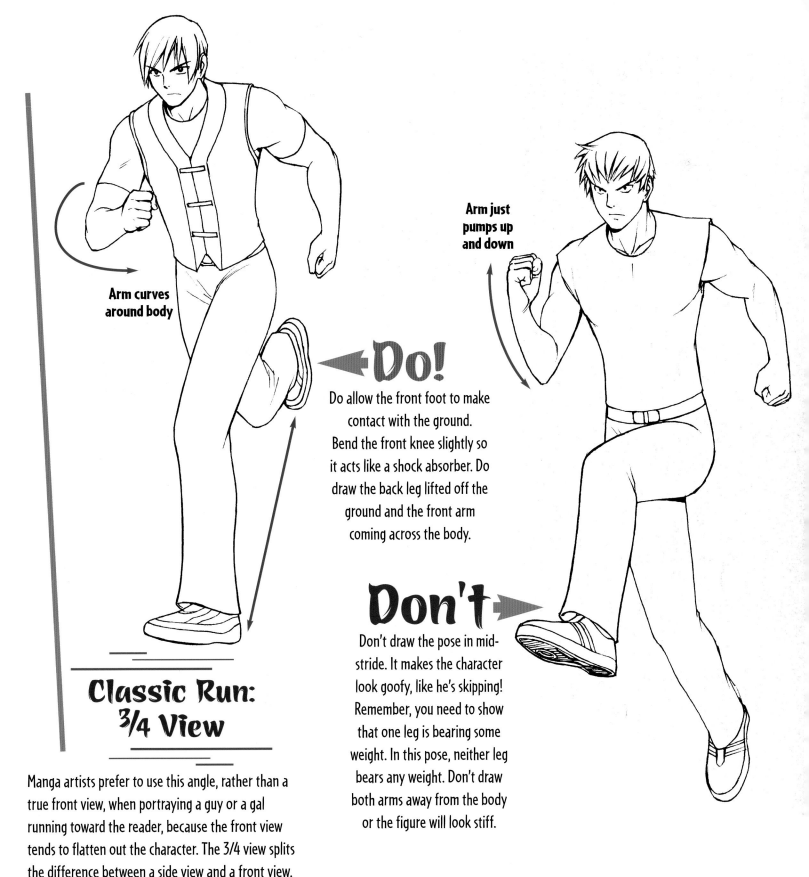

Arm curves around body

Do!

Do allow the front foot to make contact with the ground. Bend the front knee slightly so it acts like a shock absorber. Do draw the back leg lifted off the ground and the front arm coming across the body.

Arm just pumps up and down

Don't

Don't draw the pose in mid-stride. It makes the character look goofy, like he's skipping! Remember, you need to show that one leg is bearing some weight. In this pose, neither leg bears any weight. Don't draw both arms away from the body or the figure will look stiff.

Classic Run: 3/4 View

Manga artists prefer to use this angle, rather than a true front view, when portraying a guy or a gal running toward the reader, because the front view tends to flatten out the character. The 3/4 view splits the difference between a side view and a front view.

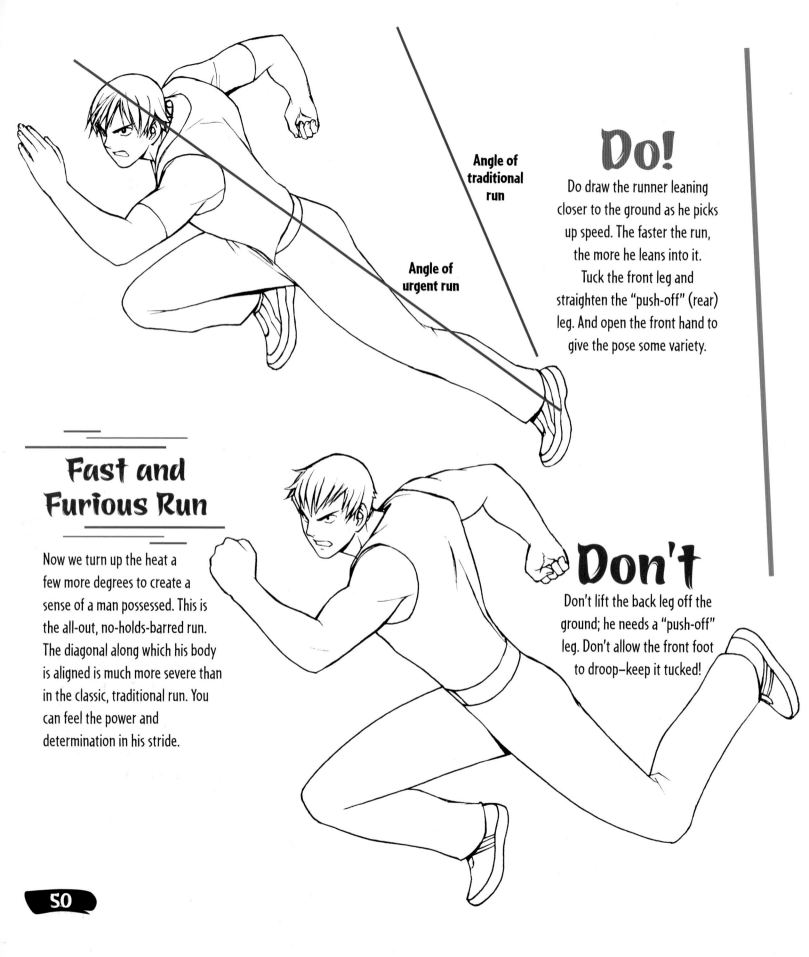

Angle of traditional run

Angle of urgent run

Do!

Do draw the runner leaning closer to the ground as he picks up speed. The faster the run, the more he leans into it. Tuck the front leg and straighten the "push-off" (rear) leg. And open the front hand to give the pose some variety.

Fast and Furious Run

Now we turn up the heat a few more degrees to create a sense of a man possessed. This is the all-out, no-holds-barred run. The diagonal along which his body is aligned is much more severe than in the classic, traditional run. You can feel the power and determination in his stride.

Don't

Don't lift the back leg off the ground; he needs a "push-off" leg. Don't allow the front foot to droop–keep it tucked!

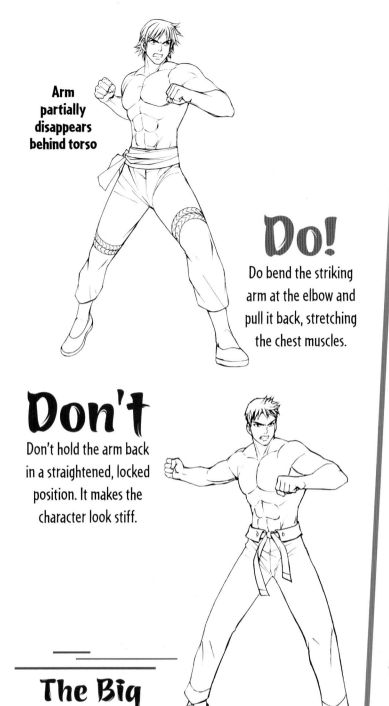

Arm partially disappears behind torso

Do!

Do bend the striking arm at the elbow and pull it back, stretching the chest muscles.

Don't

Don't hold the arm back in a straightened, locked position. It makes the character look stiff.

The Big Windup for the Big Punch

If you want a punch to look super-powerful, take it back a step to show the character cocking his arm. It's the equivalent of setting a fuse: It heightens the anticipation of the moment. Build the suspense! Show that he's going to explode with a huge punch.

The Punch

We all know what the punching arm is supposed to be doing, but what about the arm that's not punching? You can undo all your good work if the placement of the non-striking arm isn't correct.

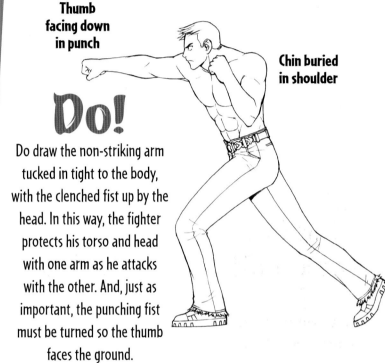

Thumb facing down in punch

Chin buried in shoulder

Do!

Do draw the non-striking arm tucked in tight to the body, with the clenched fist up by the head. In this way, the fighter protects his torso and head with one arm as he attacks with the other. And, just as important, the punching fist must be turned so the thumb faces the ground.

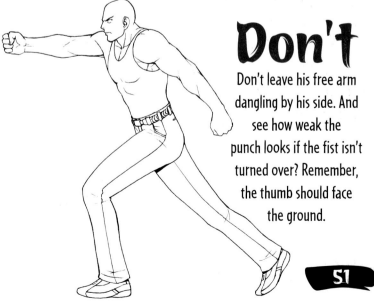

Don't

Don't leave his free arm dangling by his side. And see how weak the punch looks if the fist isn't turned over? Remember, the thumb should face the ground.

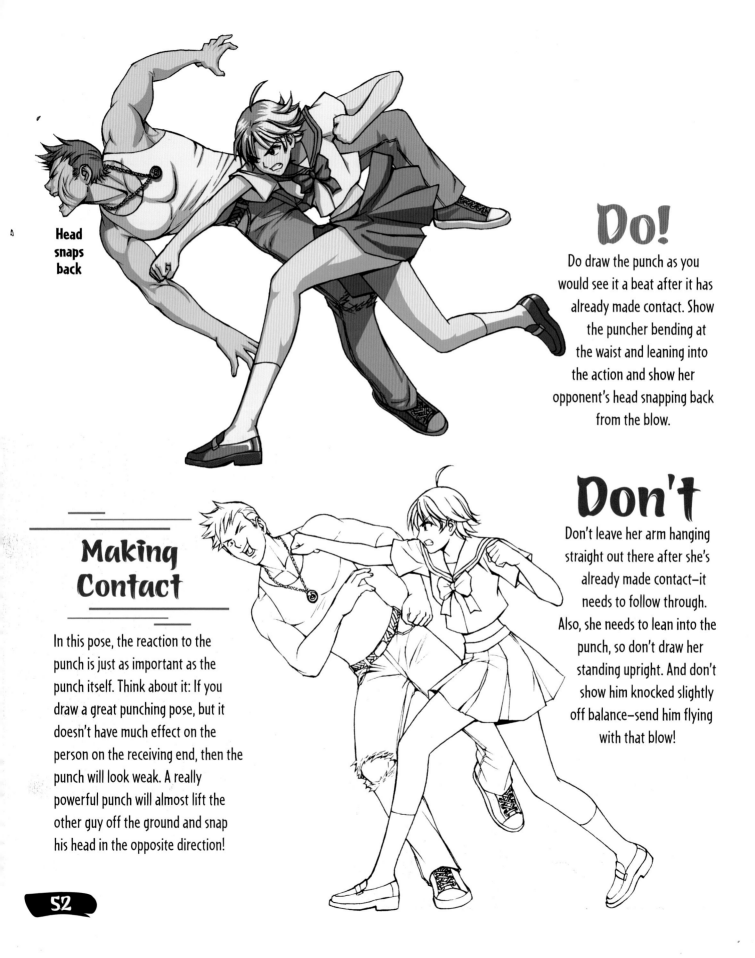

Head snaps back

Do!

Do draw the punch as you would see it a beat after it has already made contact. Show the puncher bending at the waist and leaning into the action and show her opponent's head snapping back from the blow.

Don't

Don't leave her arm hanging straight out there after she's already made contact—it needs to follow through. Also, she needs to lean into the punch, so don't draw her standing upright. And don't show him knocked slightly off balance—send him flying with that blow!

Making Contact

In this pose, the reaction to the punch is just as important as the punch itself. Think about it: If you draw a great punching pose, but it doesn't have much effect on the person on the receiving end, then the punch will look weak. A really powerful punch will almost lift the other guy off the ground and snap his head in the opposite direction!

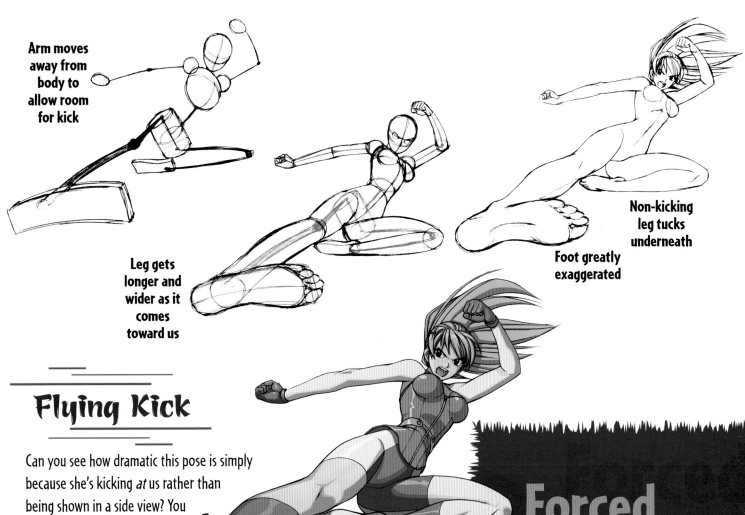

Arm moves away from body to allow room for kick

Leg gets longer and wider as it comes toward us

Foot greatly exaggerated

Non-kicking leg tucks underneath

Flying Kick

Can you see how dramatic this pose is simply because she's kicking *at* us rather than being shown in a side view? You can *feel* the kick, because of the forced perspective. We've greatly exaggerated her kicking foot and leg while reducing the size of her torso, arms and head. This is the type of high-impact pose you can get only with forced perspective.

Hint

These poses are the extreme moments in an action sequence, so use them sparingly to create maximum impact. If you were watching a clip of a sports event on TV, these would be the highlights.

Forced Perspective

If you want to take your action poses to the next level, you've gotta start thinking about perspective. But not perspective in the ordinary sense, with vanishing lines that are used to create houses and buildings. We're talking about body-warping, extreme *forced perspective*. This is actually easier to do, and you don't need a ruler. The effect is very powerful.

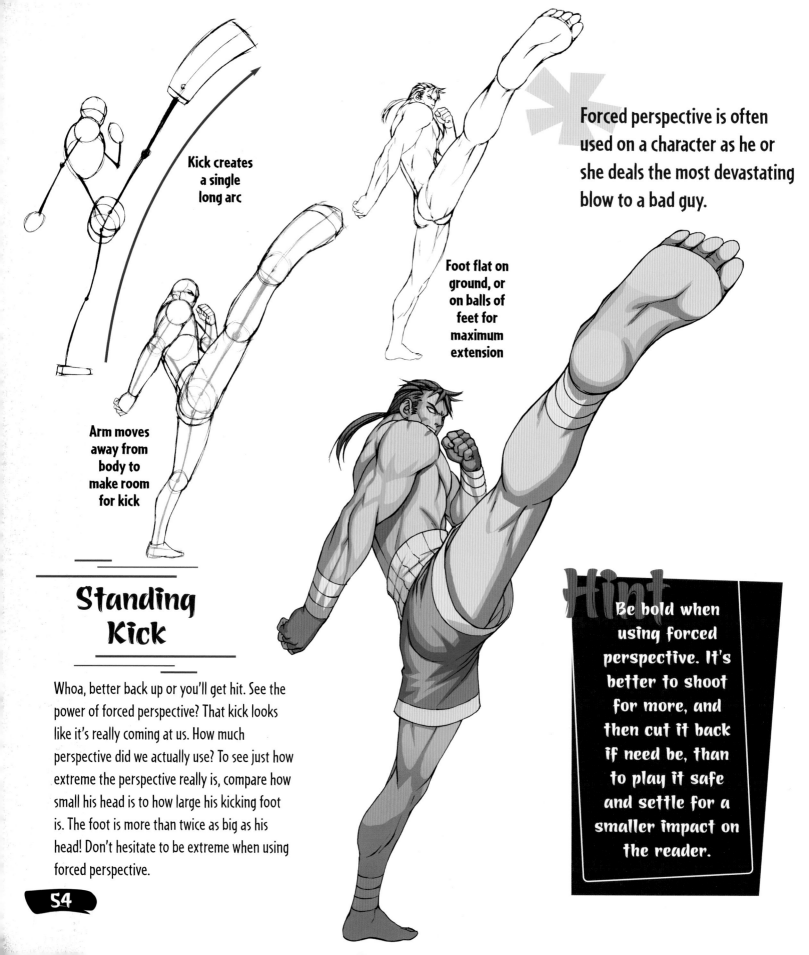

Kick creates a single long arc

Forced perspective is often used on a character as he or she deals the most devastating blow to a bad guy.

Foot flat on ground, or on balls of feet for maximum extension

Arm moves away from body to make room for kick

Standing Kick

Whoa, better back up or you'll get hit. See the power of forced perspective? That kick looks like it's really coming at us. How much perspective did we actually use? To see just how extreme the perspective really is, compare how small his head is to how large his kicking foot is. The foot is more than twice as big as his head! Don't hesitate to be extreme when using forced perspective.

Hint

Be bold when using forced perspective. It's better to shoot for more, and then cut it back if need be, than to play it safe and settle for a smaller impact on the reader.

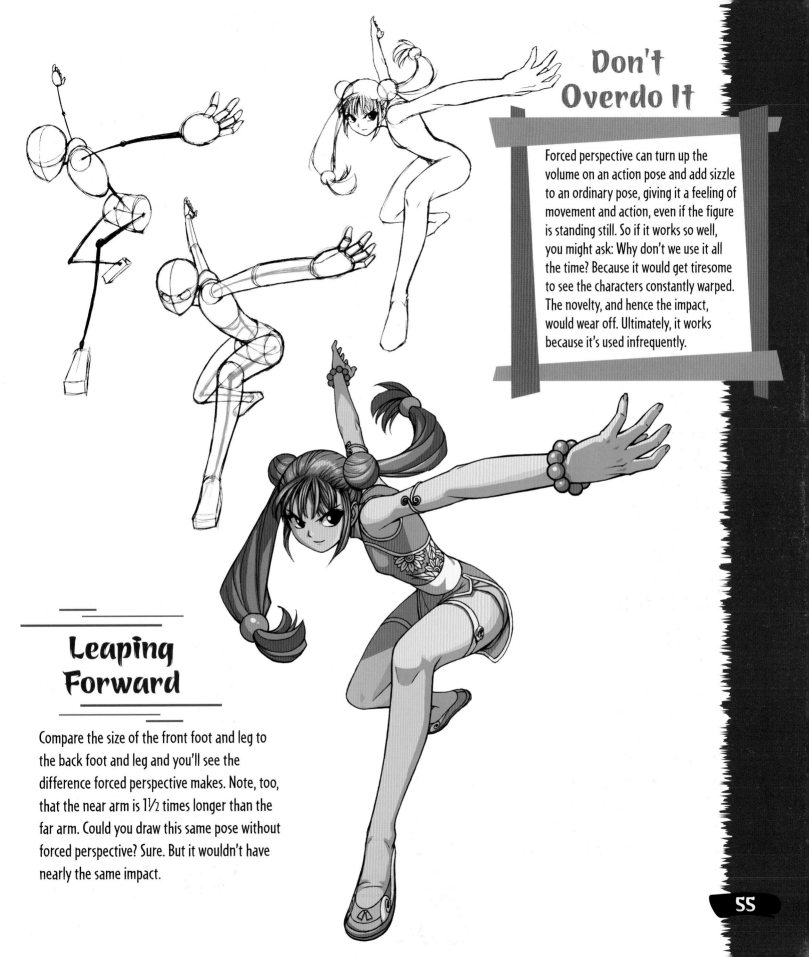

Don't Overdo It

Forced perspective can turn up the volume on an action pose and add sizzle to an ordinary pose, giving it a feeling of movement and action, even if the figure is standing still. So if it works so well, you might ask: Why don't we use it all the time? Because it would get tiresome to see the characters constantly warped. The novelty, and hence the impact, would wear off. Ultimately, it works because it's used infrequently.

Leaping Forward

Compare the size of the front foot and leg to the back foot and leg and you'll see the difference forced perspective makes. Note, too, that the near arm is 1½ times longer than the far arm. Could you draw this same pose without forced perspective? Sure. But it wouldn't have nearly the same impact.

Extreme Fight Scenes

Here's a setup frequently used in shonen graphic novels and anime shows: the clash of the fighters. In American comics, two enemies typically stand their ground and pummel each other senseless. But a shonen fight scene heightens the anticipation, tension and excitement well before the players are even close enough to throw a punch!

Instead of standing and fighting at close range, these guys square off like duelists and then charge at each other, full steam. Their fists are cocked, ready to strike. The result will be an explosive impact. Which one will win, the guy on the left or the guy on the right? If you draw it well, the reader is certain to stick around to find out!

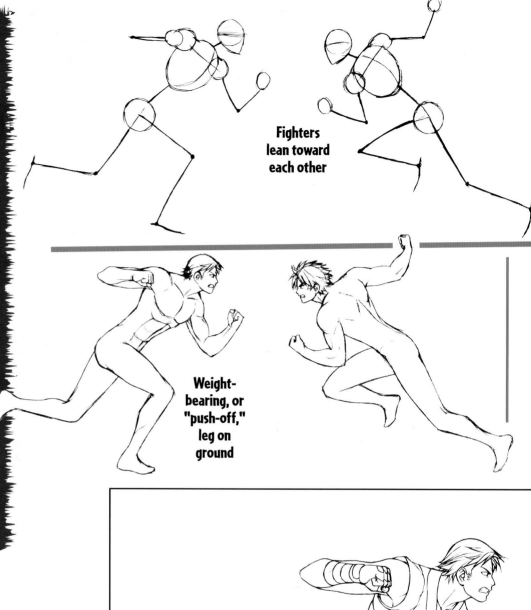

Fighters lean toward each other

Weight-bearing, or "push-off," leg on ground

Running Start: Side View

Note how the bodies (torsos) of both characters twist as they run. This helps to avoid a flat look. Many beginners draw side views with the body facing directly sideways. Try to avoid that when your character is in a heavy action pose. Rotate the trunk of the body instead.

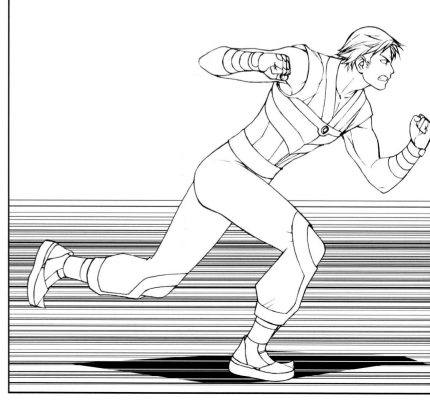

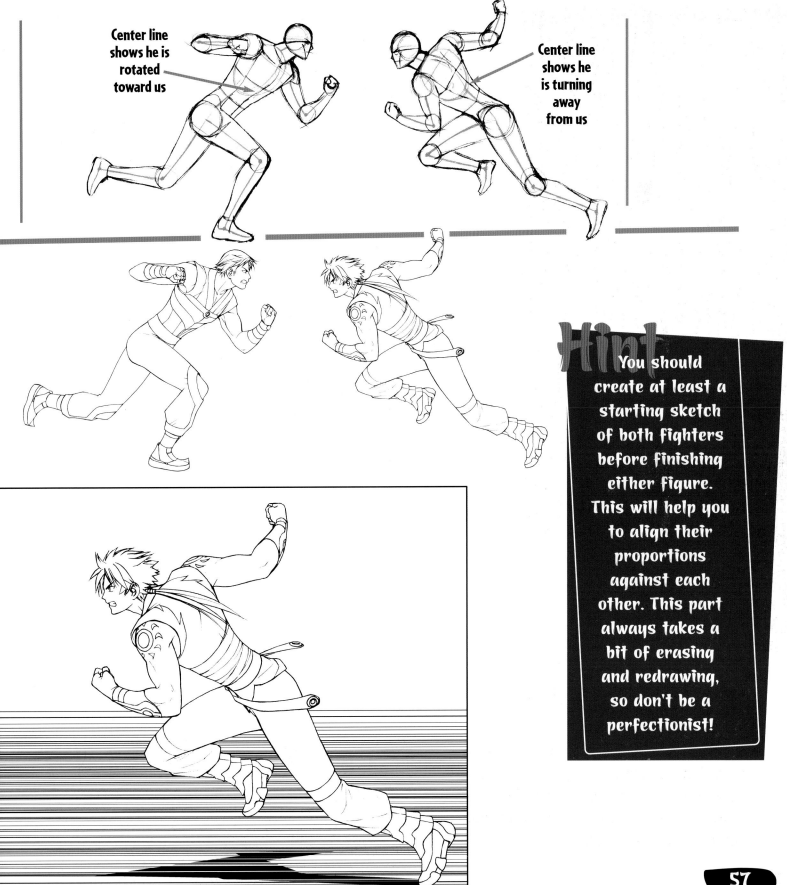

Center line shows he is rotated toward us

Center line shows he is turning away from us

Hint
You should create at least a starting sketch of both fighters before finishing either figure. This will help you to align their proportions against each other. This part always takes a bit of erasing and redrawing, so don't be a perfectionist!

Running Start: ¾ View

The thing to remember about drawing a clash in the ¾ view is that you must favor your hero. Your reader should be able to see the hero's face clearly, but only the back of the opponent's head, as if the reader is looking over his shoulder.

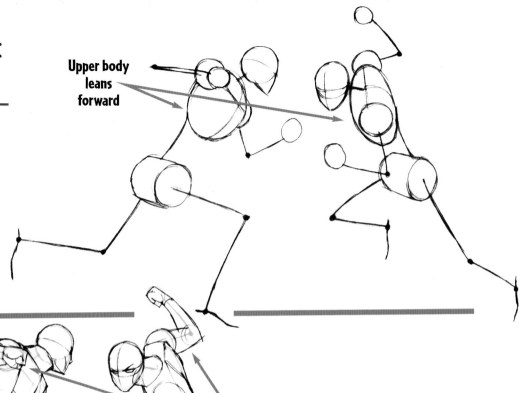

Upper body leans forward

Punching arm cocked back

Notice how the characters' heads are so close together in this pose. This adds to the intensity of the action.

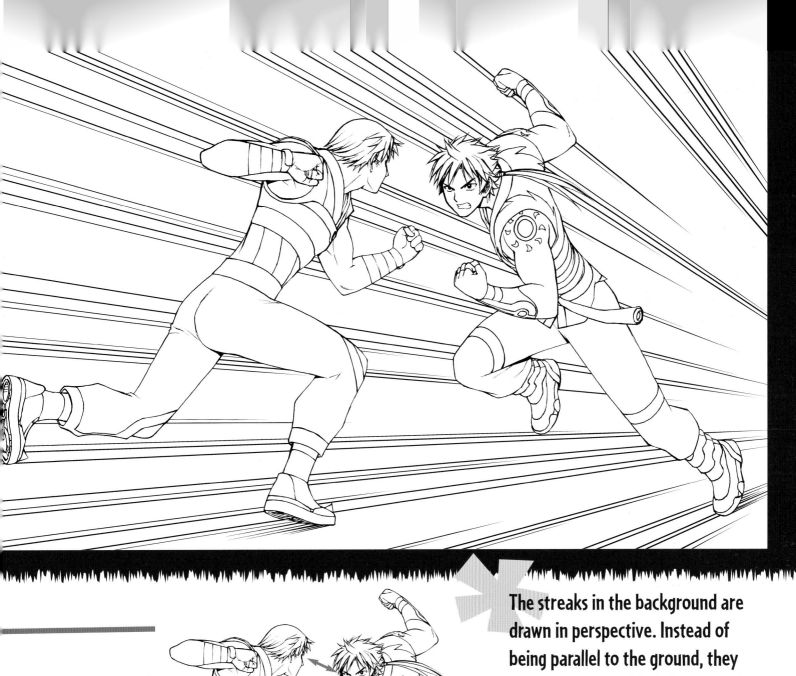

Fighters lock eyes

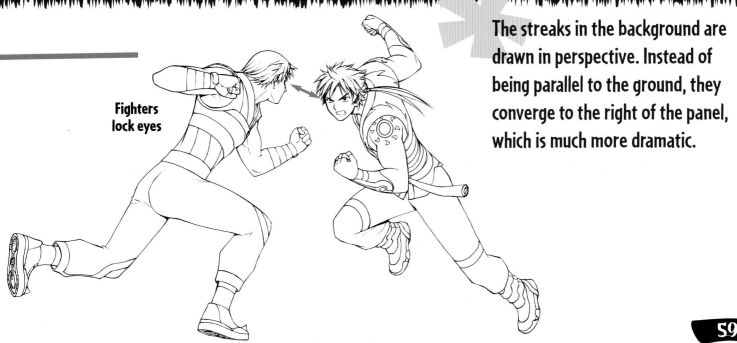

The streaks in the background are drawn in perspective. Instead of being parallel to the ground, they converge to the right of the panel, which is much more dramatic.

Impact: Side View

In a vicious clash, both characters may emerge from the first impact without having hurt each other—that is, if their martial arts abilities are equal. But sooner or later, one of them is going to land that powerhouse punch and tilt the fight decisively in his favor. You can't very well have one fighter stand there waiting to be hit, so both characters have to throw a punch simultaneously. But the winning fighter moves quickly to avoid the strike and counterpunch at the same time.

Losing fighter stands more upright

Winning fighter puts all his weight into punch

Punching arm misses opponent's head by a decent margin

Negative space gives room to frame head

Missed punch is fully extended

Legs overlap

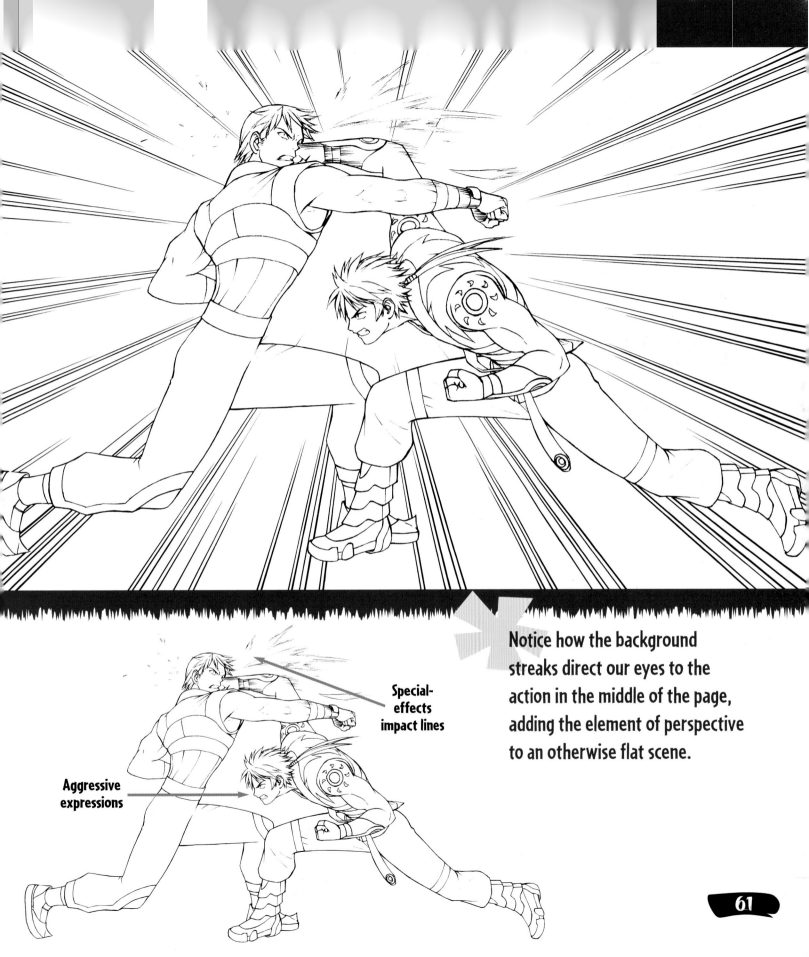

Special-effects impact lines

Aggressive expressions

Notice how the background streaks direct our eyes to the action in the middle of the page, adding the element of perspective to an otherwise flat scene.

Impact: 3/4 View

Can you see where the foreshortening is most noticeable in this picture? It's in the losing fighter's punching arm. The arm is shortened to bring it into the correct perspective, because it is traveling—not sideways, but *away from us*, or, if you prefer, *deeper* into the picture plane.

Opponent's punch clears head by a wide margin

Head placed low on shoulders

Foot perpendicular to ground

Deep bend in knees

Foot perpendicular to ground

62

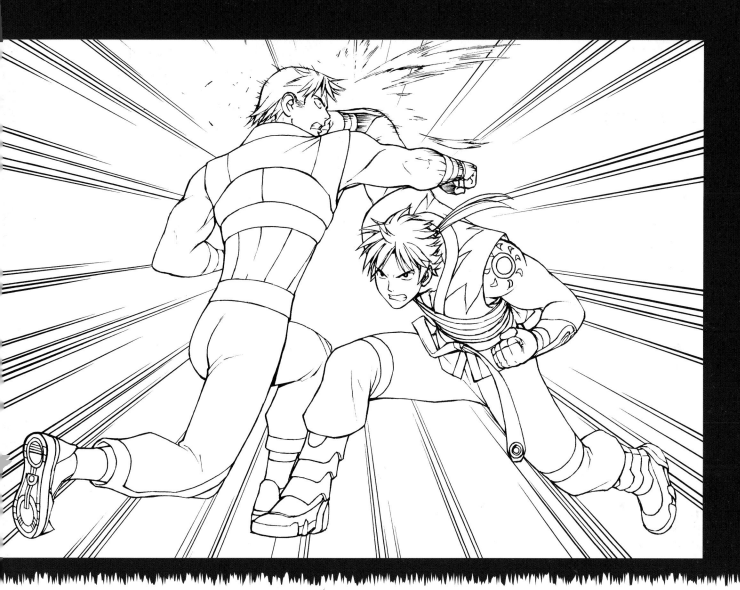

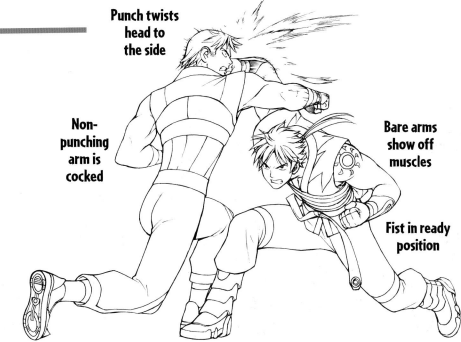

Punch twists head to the side

Non-punching arm is cocked

Bare arms show off muscles

Fist in ready position

Here's what you've been waiting for: the clash of the fighters in full color. Can't you almost see the sweat flying off the page?

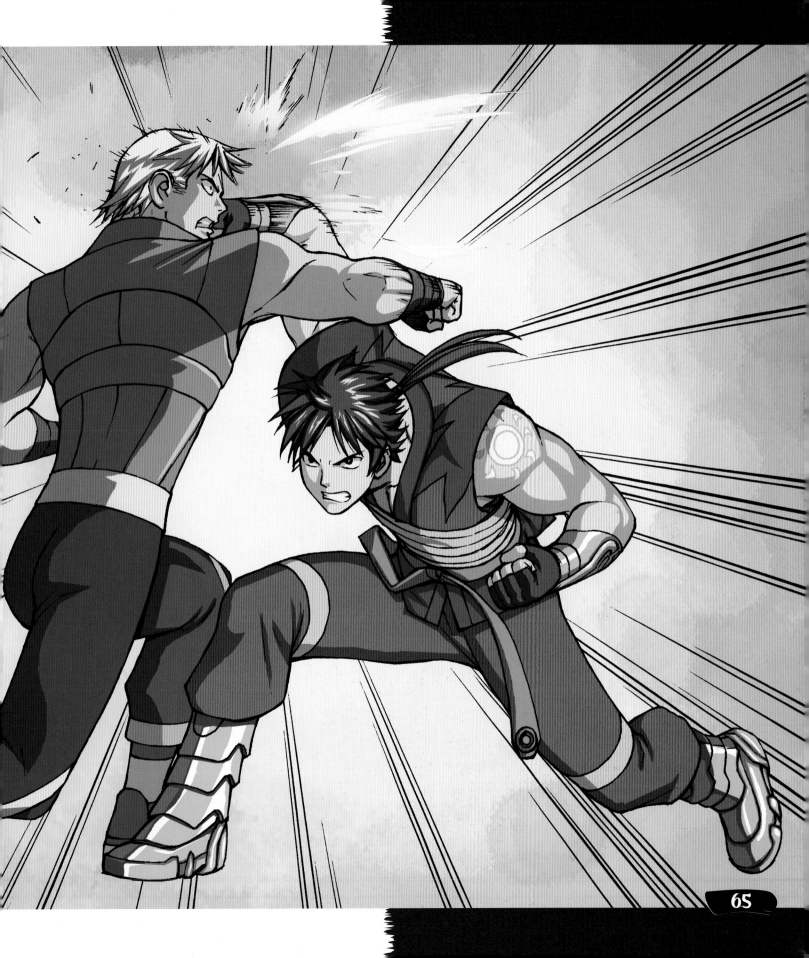

Panel Design for Action Comics

action-style manga has to be full of energy, and part of the energy in a graphic novel comes from the panel design. You don't want all basic squares—too boring. And you certainly don't want all wild shapes—too annoying. Mixing them up keeps the reader on his or her toes.

Basic panels, like squares and rectangles, are best to use when establishing the foundation of the story or conveying important information. As the story gets rolling and picks up speed, you can throw in a few stylized panels to shake things up and break the monotony. Here are a variety of panel designs you can try.

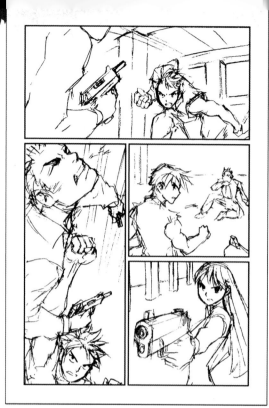

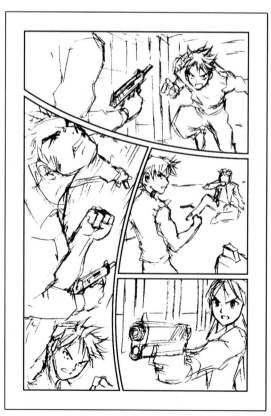

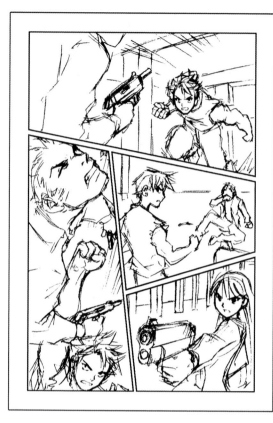

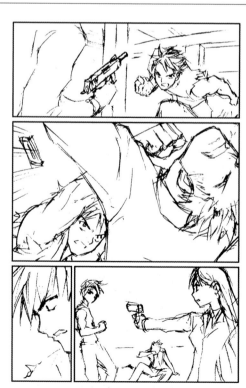

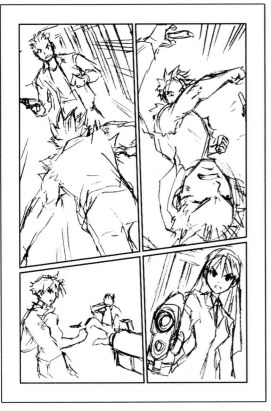

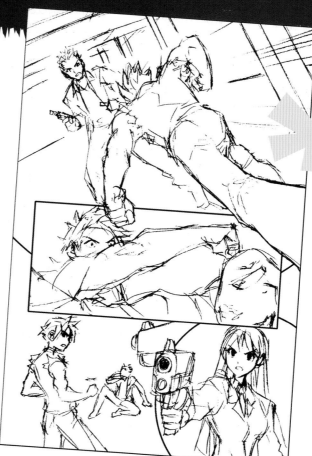

Don't be afraid to let the characters overlap or even break through the panels!

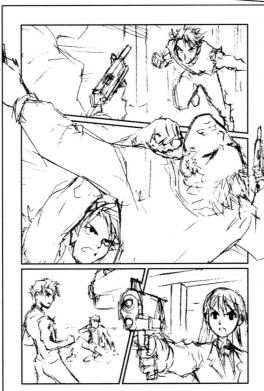

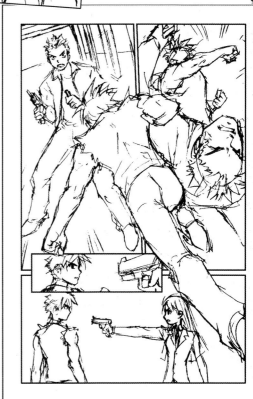

Hint

A good trick to try is the "insert" panel— a panel within a panel that highlights something happening in the larger panel.

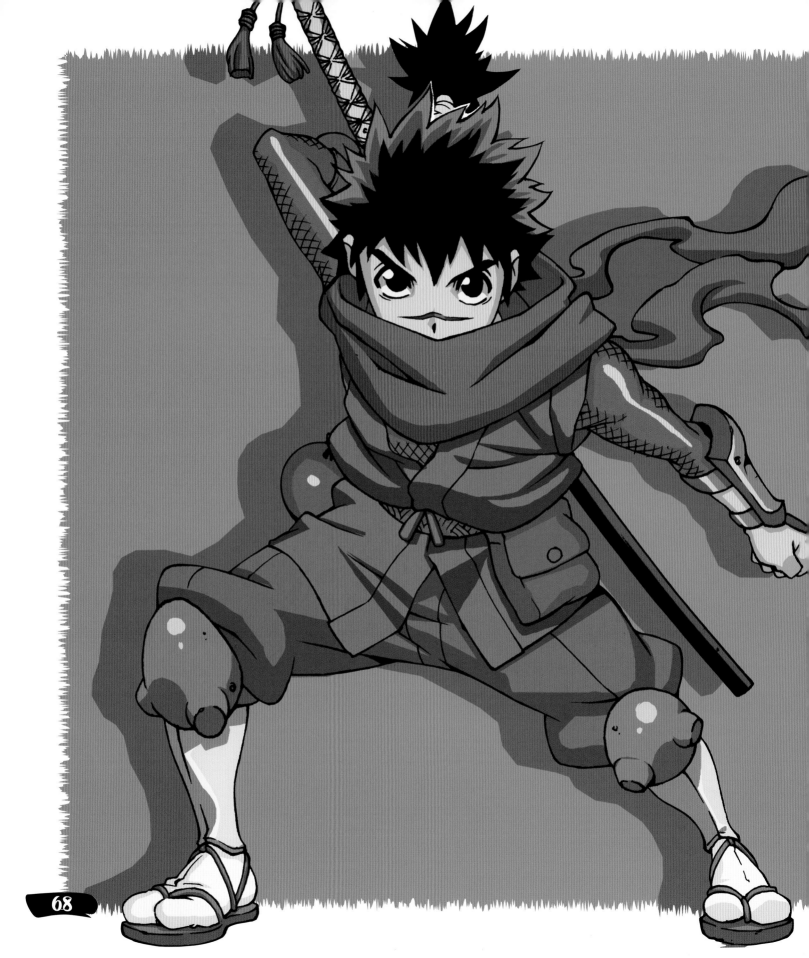

Samurai Characters

Samurai stories are exploding in popularity in manga, and they bring plenty of action to shonen-style graphic novels. Whereas samurai used to be portrayed as adult men, today's samurai include teens—sometimes even young boys—and girl fighters as well. All you need to be a samurai is the right equipment, a cause beyond your own personal ambitions, and an indomitable fighting spirit. This chapter will show you all you need to know to draw shonen-style samurai.

Samurai
Samurai Boy Turnarounds

One of the questions I'm often asked is, How do I make my character look the same when I draw him at different angles? Here's what I, and many artists, do, and you can try, too: "turnarounds." Turn the character around 180 degrees and draw him in all the stages in between. Nothing will help you get to know a character like doing turnarounds. It's time well spent. Let's draw some turnarounds of a young samurai.

As you probably gathered from reading lots of manga and watching anime on TV, you should never let a samurai's size or youth fool you. It's not how tall he is that counts in a fight, it's the size of his heart! Younger samurai are often dressed in bunchy garments, which make them look more serious about fighting. Remember, they're actually pretty skinny under all that fabric!

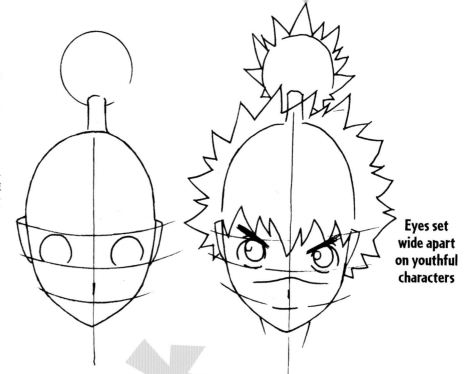

Eyes set wide apart on youthful characters

The mouth and nose are placed low on the face for young teens, including girls.

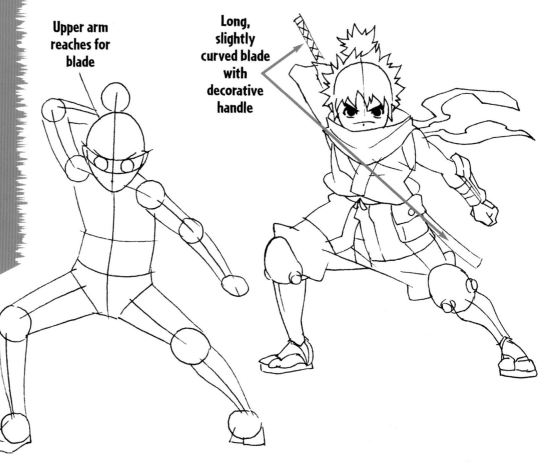

Upper arm reaches for blade

Long, slightly curved blade with decorative handle

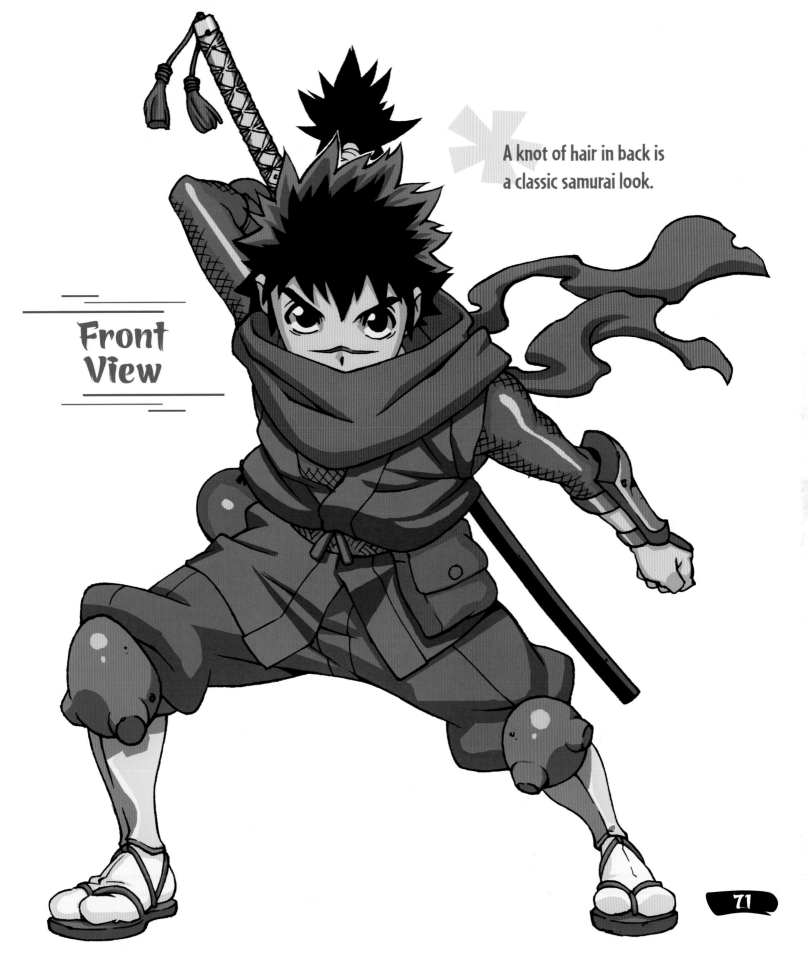

Front
View

A knot of hair in back is
a classic samurai look.

Knot of hair

Spikey hair

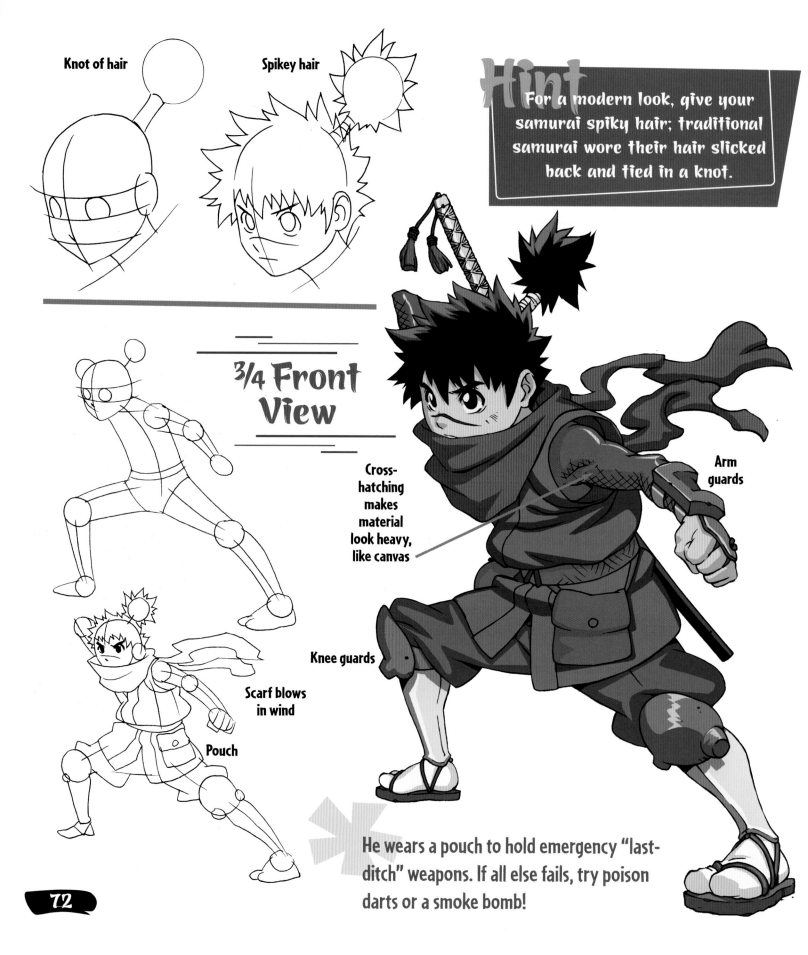

Hint

For a modern look, give your samurai spiky hair; traditional samurai wore their hair slicked back and tied in a knot.

¾ Front View

Cross-hatching makes material look heavy, like canvas

Arm guards

Knee guards

Scarf blows in wind

Pouch

He wears a pouch to hold emergency "last-ditch" weapons. If all else fails, try poison darts or a smoke bomb!

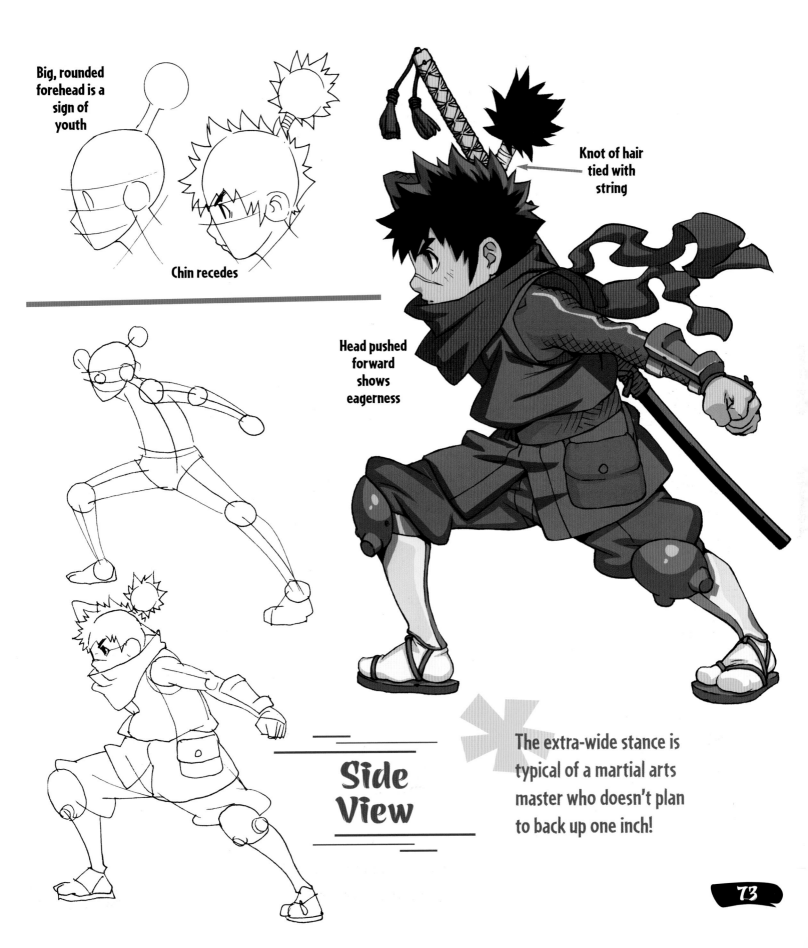

Big, rounded forehead is a sign of youth

Chin recedes

Knot of hair tied with string

Head pushed forward shows eagerness

Side View

The extra-wide stance is typical of a martial arts master who doesn't plan to back up one inch!

73

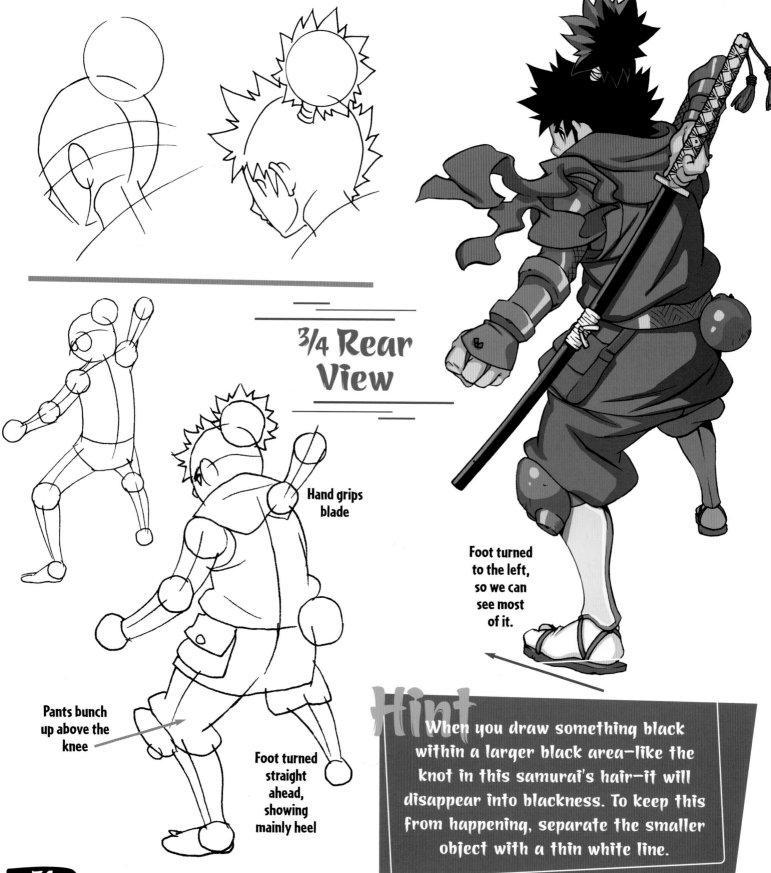

3/4 Rear View

Hand grips blade

Pants bunch up above the knee

Foot turned straight ahead, showing mainly heel

Foot turned to the left, so we can see most of it.

Hint

When you draw something black within a larger black area—like the knot in this samurai's hair—it will disappear into blackness. To keep this from happening, separate the smaller object with a thin white line.

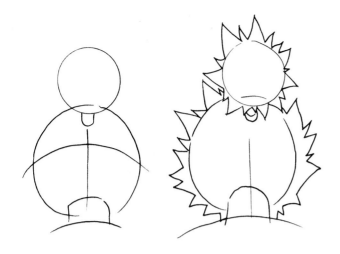

The New Samurai

The strength of manga is its ability to relate the characters to the reader. Teens don't necessarily want to read story after story about 30-year-old samurai men, even if they are great stories. In order to capture the imagination of younger readers, the samurai heroes had to change as well. And the Japanese creators of samurai stories were forward-looking in breaking their own conventions, so that today we think nothing of it when introduced to a 14-year-old samurai warrior. But it's taken some growing pains to get here!

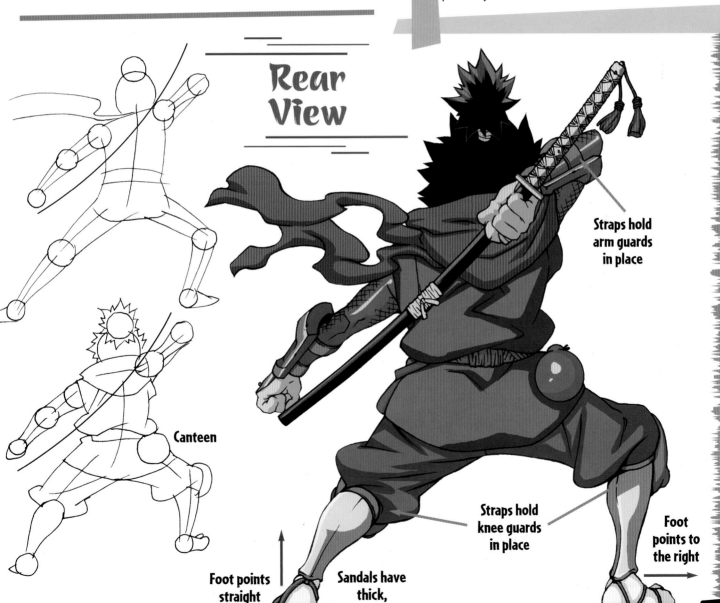

Rear View

Straps hold
arm guards
in place

Canteen

Straps hold
knee guards
in place

Foot
points to
the right

Foot points
straight
ahead

Sandals have
thick,
flat soles

Girl Samurai

She should look like a combination of homecoming queen and professional hit man all rolled into one. She's a dangerous beauty, but her wide, innocent eyes and round face signal to the reader that she's one of the good guys. Angular faces and beady eyes are reserved for bad types.

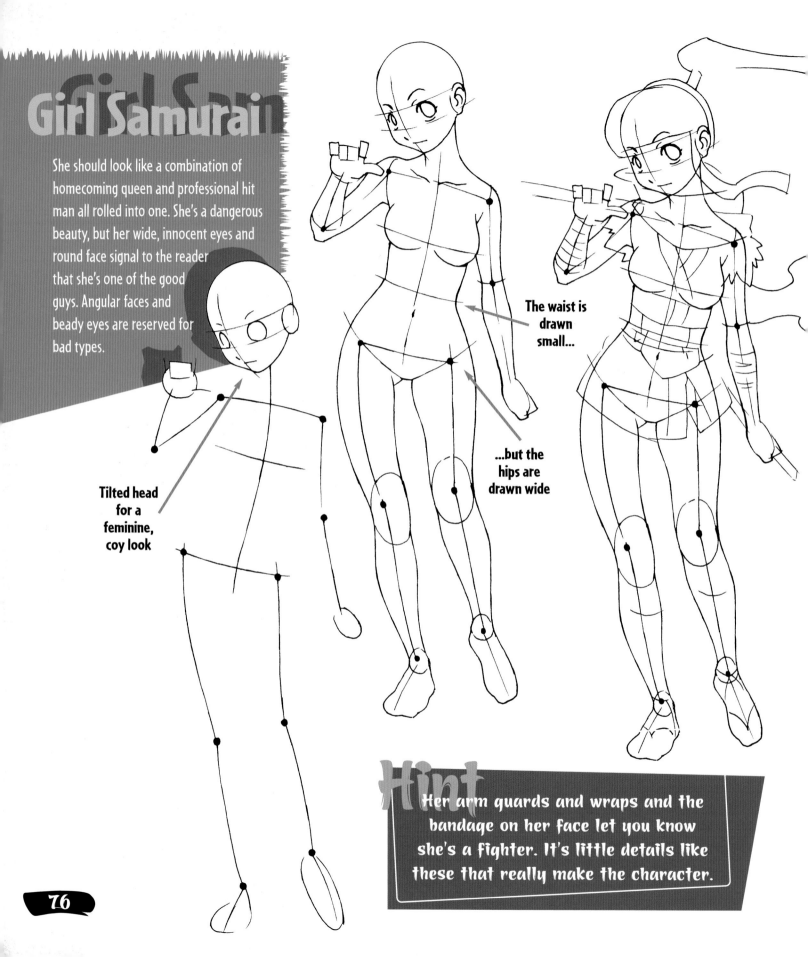

Tilted head for a feminine, coy look

The waist is drawn small...

...but the hips are drawn wide

Hint

Her arm guards and wraps and the bandage on her face let you know she's a fighter. It's little details like these that really make the character.

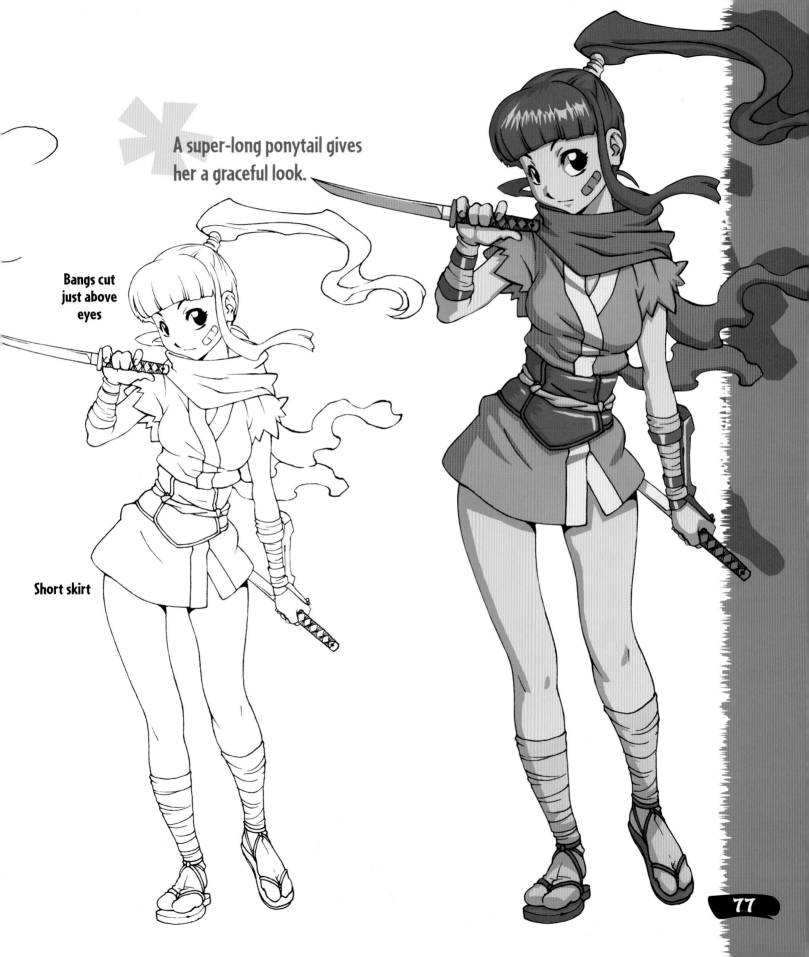

A super-long ponytail gives her a graceful look.

Bangs cut just above eyes

Short skirt

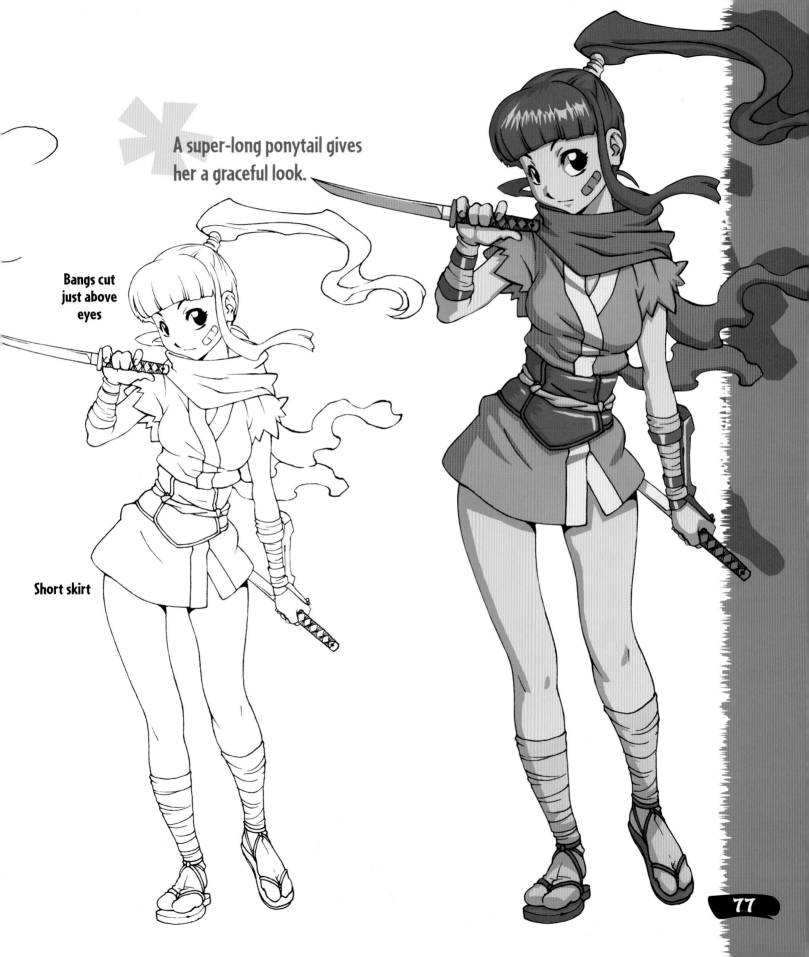

77

Bad Samurai!

Bad
Samurai!

How long did you think it would take most manga artists to get bored with drawing only samurai heroes and start drawing ruthless, vicious samurai as well? Yep, about five minutes. Bad guys are fun to draw!

Street Warrior

He's less of a martial arts devotee and more of the muscle behind a gang of thugs. Hey, no thugs, no story. Gotta have the thugs. But first, he's going to create a little mayhem among the peasants and the common folk. Like making sure they pay him for "protection"–against himself!

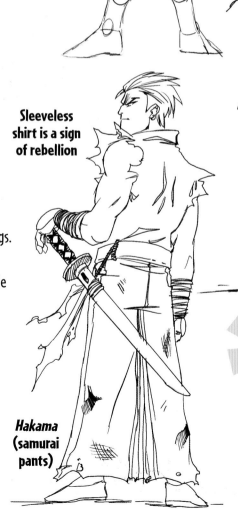

Sleeveless shirt is a sign of rebellion

Hakama (samurai pants)

* Samurai are humble : Pretentious, showy muscles mean he's not a true samurai.

Evil Samurai Grandmaster

Just because he's collecting social security doesn't mean he's a pushover–not when it comes to Asian martial arts. Some of the deadliest adversaries go for the early bird special at the local sushi diner. He knows all the moves; after all, he invented most of them! He's what is known as a grandmaster. And he's the samurai you go to if you want to learn the deadly fighting arts.

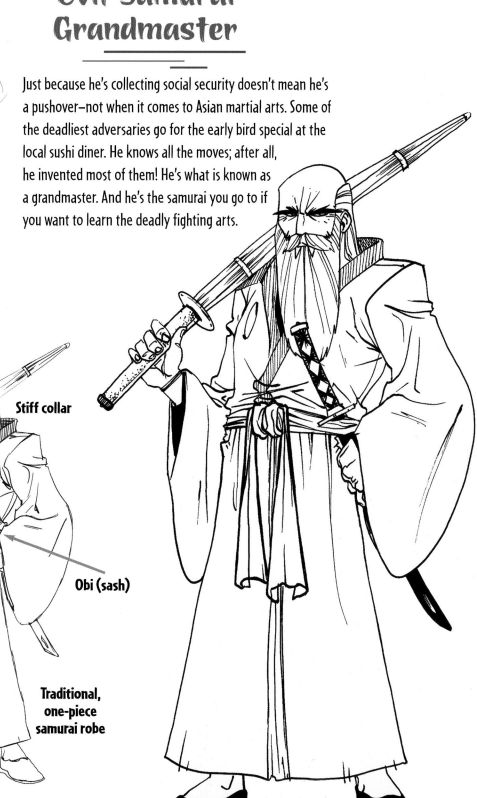

Stiff collar

Obi (sash)

Traditional, one-piece samurai robe

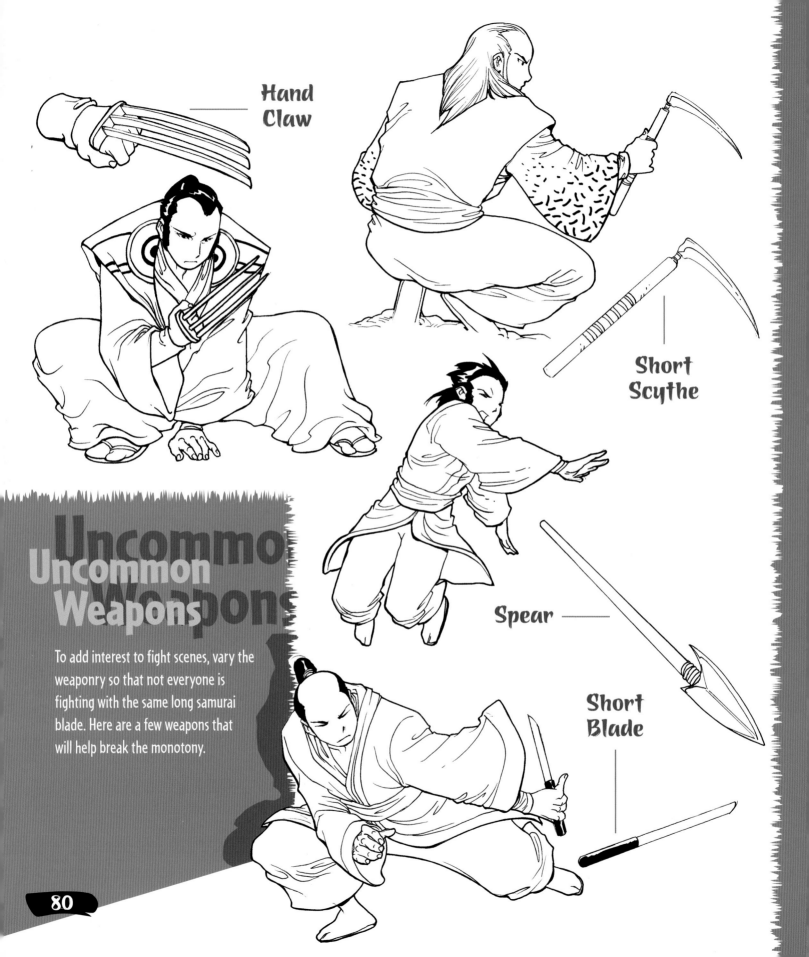

Hand
Claw

Short
Scythe

Spear

Short
Blade

Uncommon Weapons

Uncommon Weapons

To add interest to fight scenes, vary the weaponry so that not everyone is fighting with the same long samurai blade. Here are a few weapons that will help break the monotony.

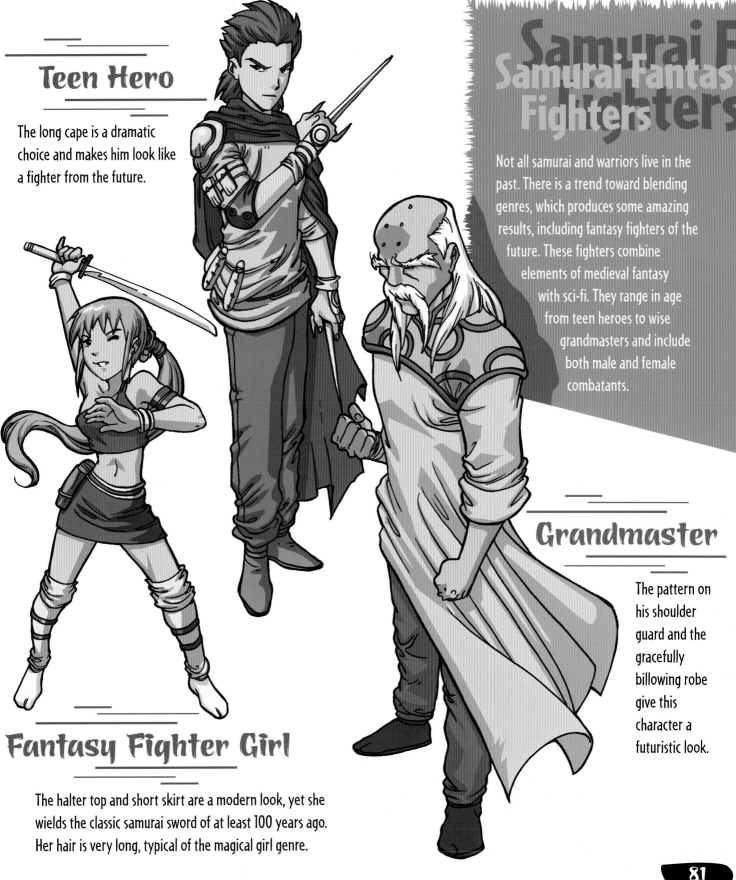

Teen Hero

The long cape is a dramatic choice and makes him look like a fighter from the future.

Fantasy Fighter Girl

The halter top and short skirt are a modern look, yet she wields the classic samurai sword of at least 100 years ago. Her hair is very long, typical of the magical girl genre.

Not all samurai and warriors live in the past. There is a trend toward blending genres, which produces some amazing results, including fantasy fighters of the future. These fighters combine elements of medieval fantasy with sci-fi. They range in age from teen heroes to wise grandmasters and include both male and female combatants.

Grandmaster

The pattern on his shoulder guard and the gracefully billowing robe give this character a futuristic look.

81

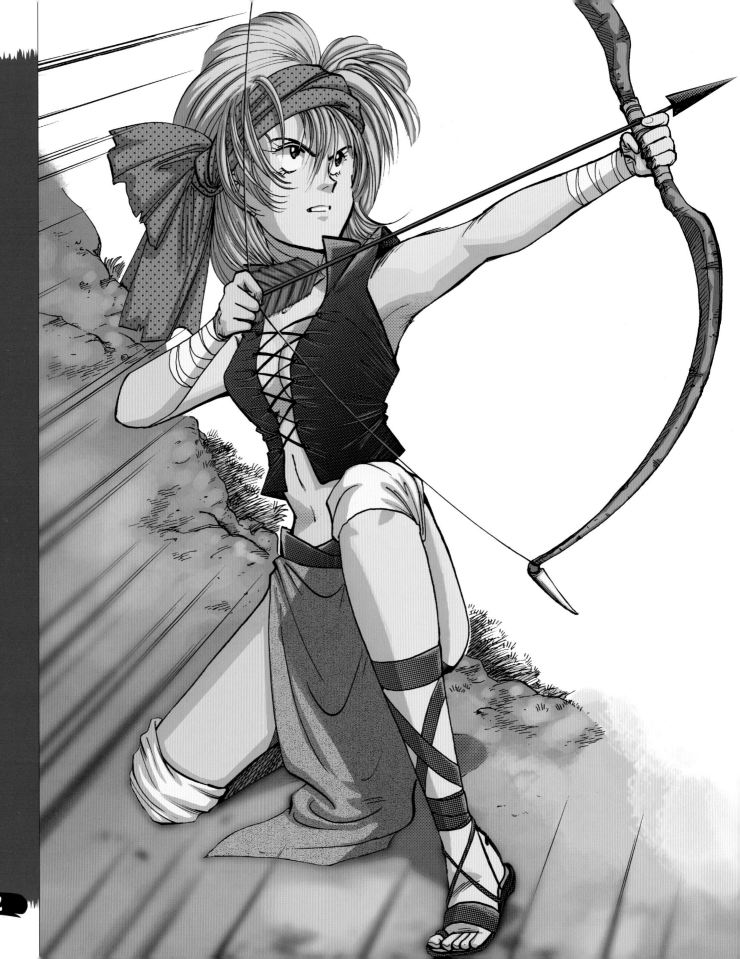

Fighter Girls

in the rough-and-tumble world of action comics, you better know how to fight or know how to run—and manga characters never run! Especially the beautiful girls with martial arts and weapons skills. Female fighting masters move from one appealing pose to another, retaining a sense of controlled fury. The trick to drawing them is to keep their moves athletic and feminine. Let's take a look.

Flying Ninja

Flying N

She's throwing four-pointed stars, called *shurikens*, which she keeps hidden in a pouch. These deadly weapons are tossed backhand like disks. They rotate as they spin toward the opponent. As she tosses the shurikens with one hand, the other is already on the handle of the blade, ready to follow up the attack.

Extend arm

Bend arm

Bend knee

Extend leg

Hair is part of action

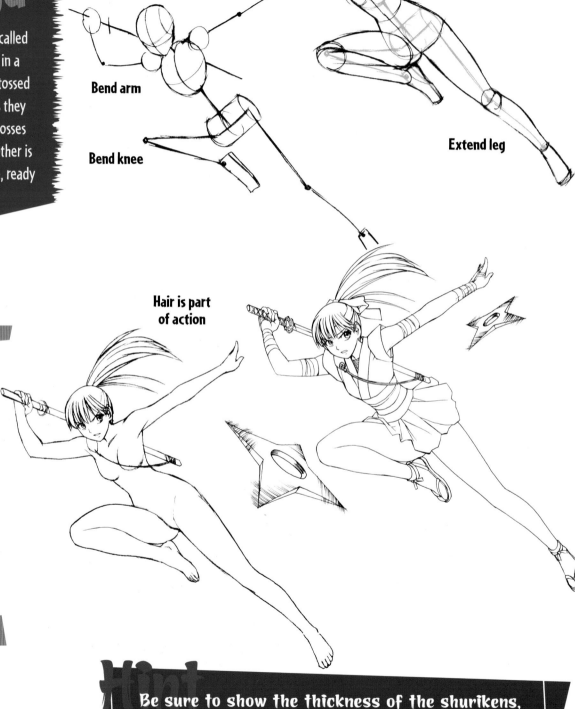

Girl Power!

Fighter girls are crossover characters who capture both male and female fans. This is important for publishers, because the female market for manga is huge. So featuring strong female fighting characters in boys' action-style manga makes good strategic sense—and great stories.

Hint

Be sure to show the thickness of the shurikens, so they don't look two-dimensional.

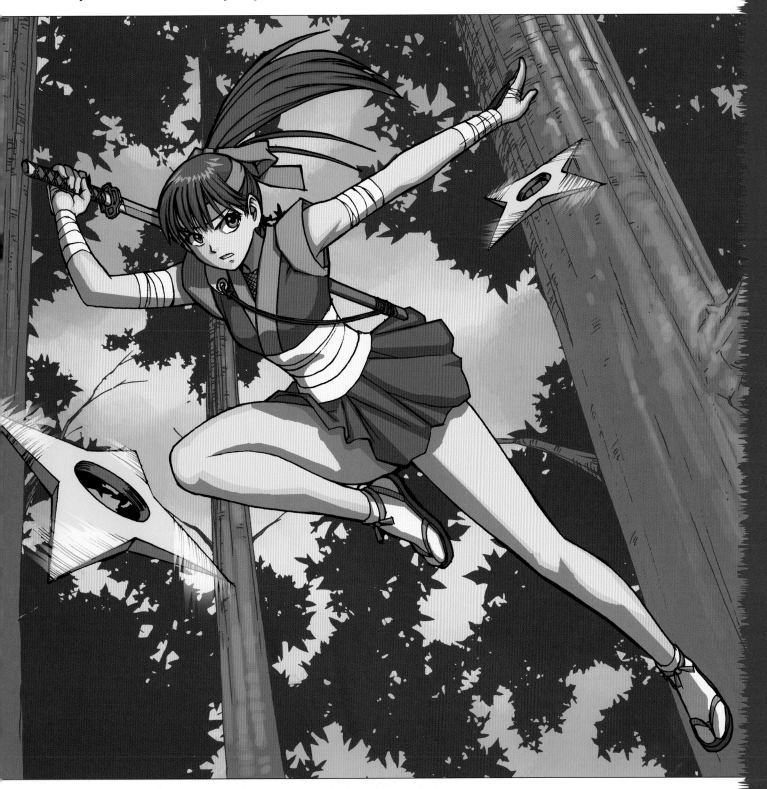

Spy Girl

Spy Girl

Here's two-fisted firepower coming right at you! I'll pit this gorgeous gunfighter against anyone. Severely foreshorten the near arm so that we see only one fist and an enlarged gun nozzle aimed directly at us. The far arm is foreshortened, too, but not as severely.

Guns are built on simple rectangles

Hair flies to show action

Shoulders tensed and up

Deep bend in supporting knee

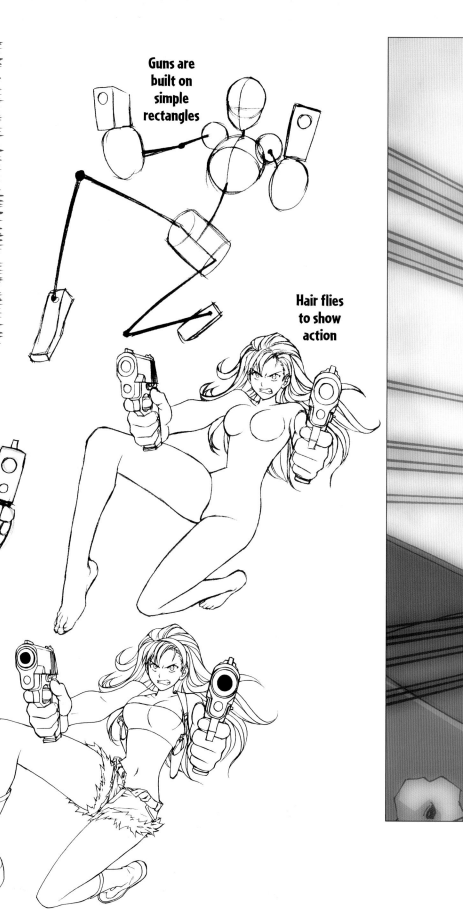

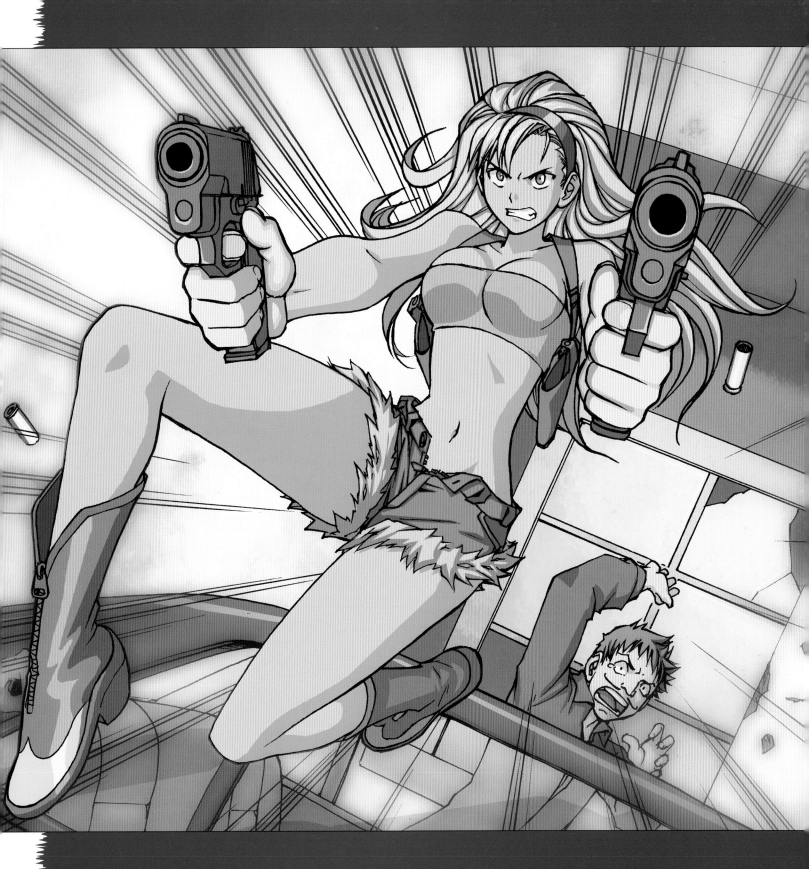

Sharpshooter

In manga, you can never have too big a gun. Here's an agent on a top-secret assignment, waiting for her big moment. She rests the gun on top of her knee and wedges it under her arm. The rear foot cannot be flat on the floor. The ball of the foot supports her weight, and the heel is pressed against her buttocks.

Gun rests on knee

Torso straight and "ready"

Draw the gun using a ruler, for best results

Sketch the gun before arms are in place

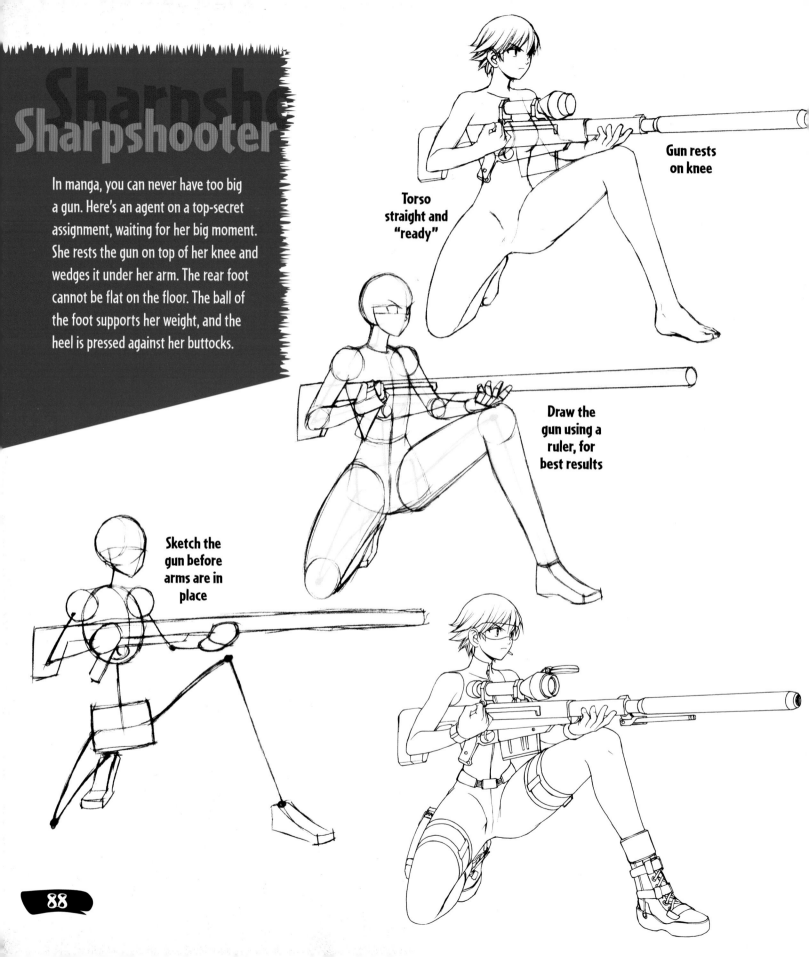

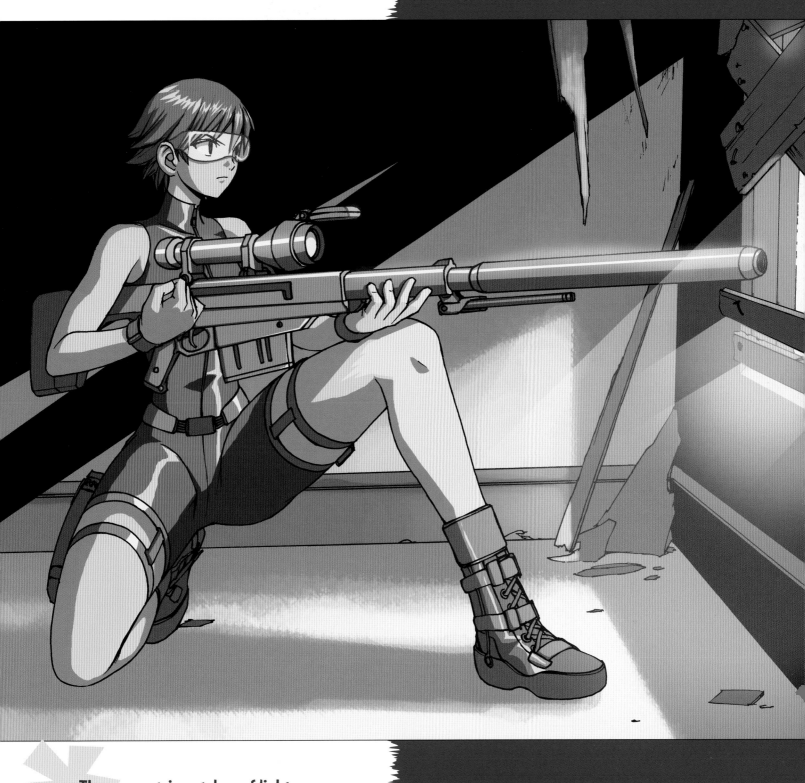

The geometric patches of light surrounded by black on the walls create the feeling of an abandoned building.

Evil Enchantress

The badder they come, the more exotically beautiful they're drawn. This is how artists create a push-pull tug of emotions in the audience. She's beautiful and alluring, yet we know we should be rooting against her. We have conflicting feelings. It gets complicated—and not just for us, but for the good guy, too. That makes for a good story.

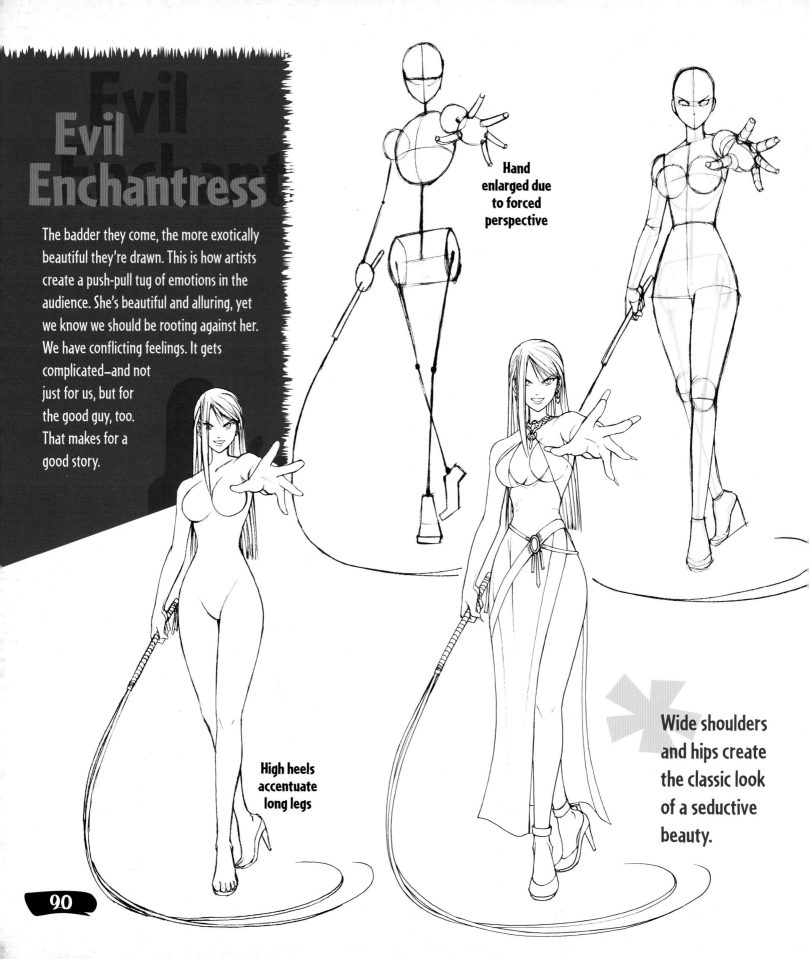

Hand enlarged due to forced perspective

High heels accentuate long legs

Wide shoulders and hips create the classic look of a seductive beauty.

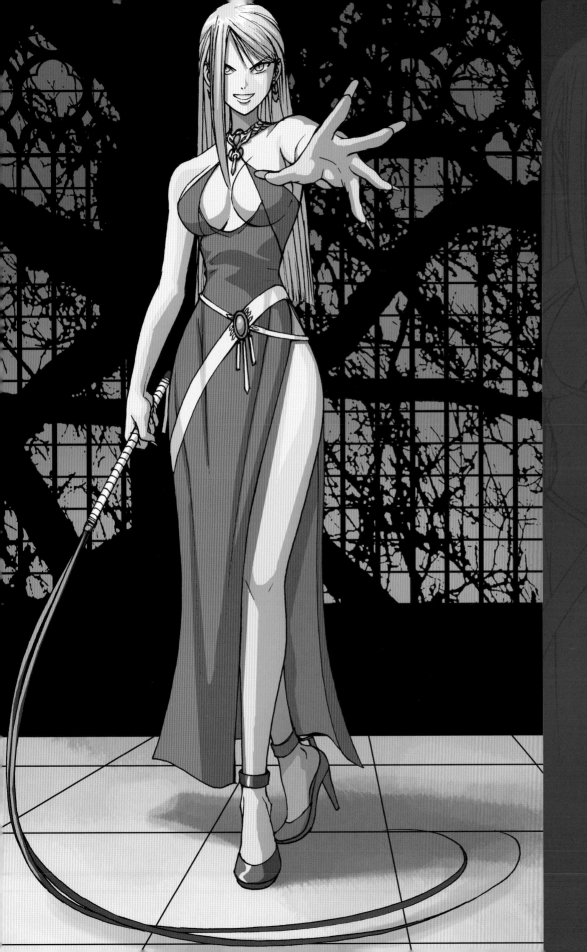

Fantasy Fighter

Fantasy Fighter

The fantasy fighter girl may be a magical girl with superpowers or, like the archer shown here, a regular human who possesses great fighting skill. Although this pose may look advanced, it's actually fairly simple to draw.

Drawing both arms in a strong straight line shows power and determination.

Supporting leg drawn at 45-degree angle

Head and body turned in opposite directions

Hint

Draw the arrow pointed up at an angle to signify that she is shooting at something larger, and therefore stronger, than she is. That makes her the underdog, which is the essence of drama.

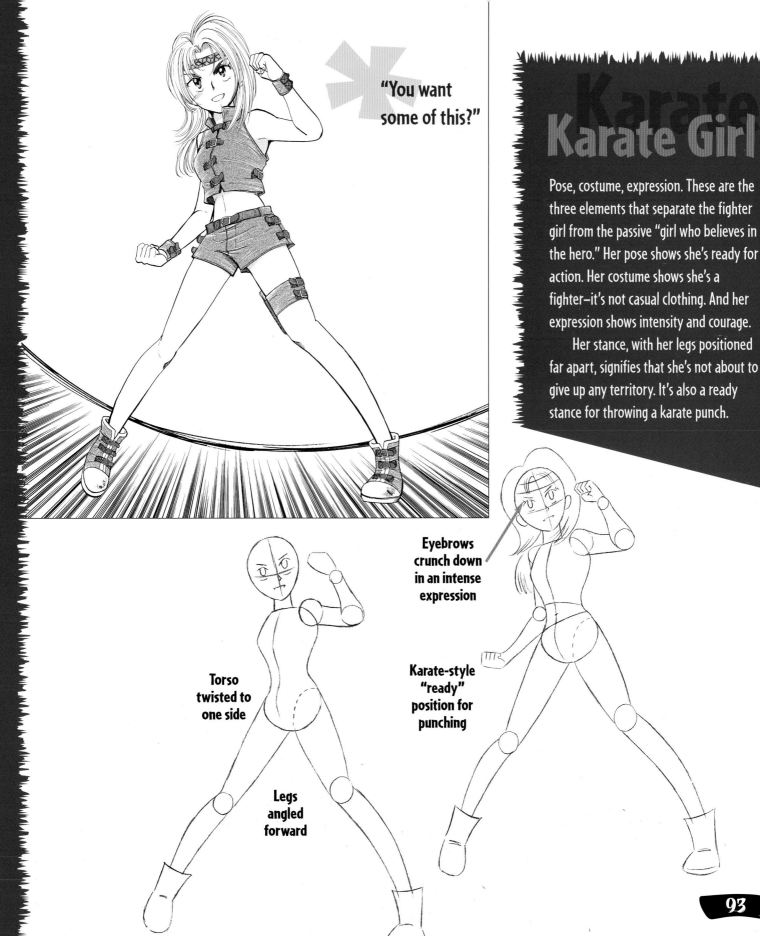

"You want some of this?"

Karate Girl

Pose, costume, expression. These are the three elements that separate the fighter girl from the passive "girl who believes in the hero." Her pose shows she's ready for action. Her costume shows she's a fighter—it's not casual clothing. And her expression shows intensity and courage.

Her stance, with her legs positioned far apart, signifies that she's not about to give up any territory. It's also a ready stance for throwing a karate punch.

Eyebrows crunch down in an intense expression

Karate-style "ready" position for punching

Torso twisted to one side

Legs angled forward

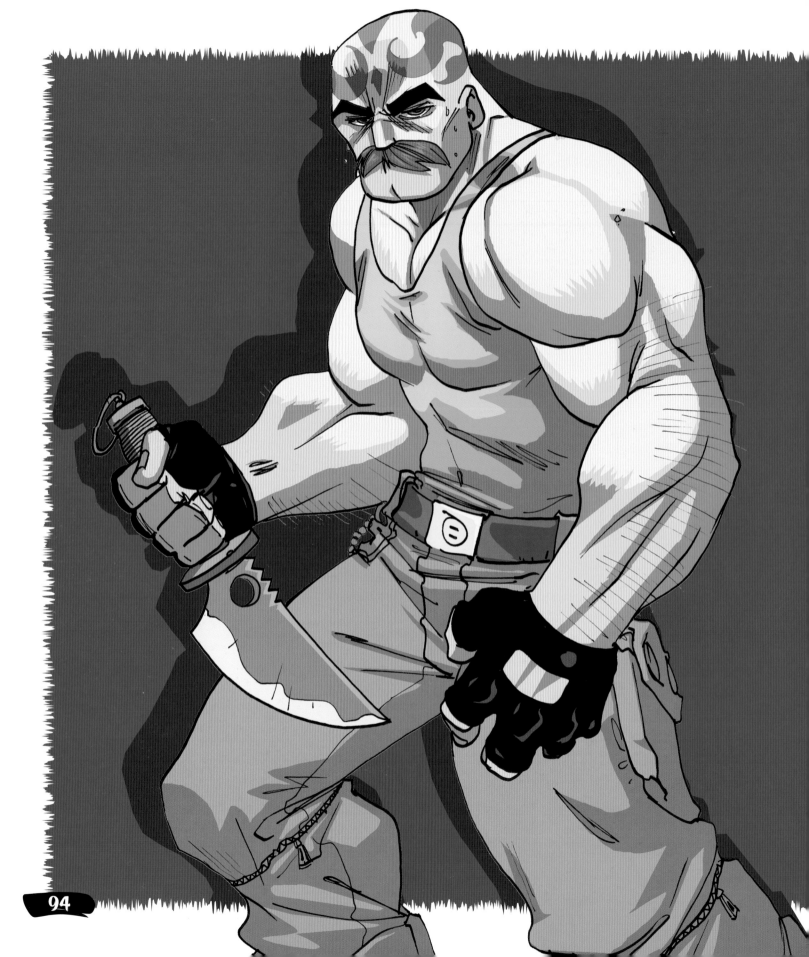

Supporting Characters

Whether you want to someday be a published *mangaka* (manga artist) or you simply draw manga for fun, it's important to be able to draw a variety of characters for two reasons: First, no story can develop if you don't have a supporting cast. Second, varying your characters makes drawing more fun and your work more appealing to readers. In this chapter, you'll learn how to draw some of the most popular supporting characters in shonen manga.

Teen Punk

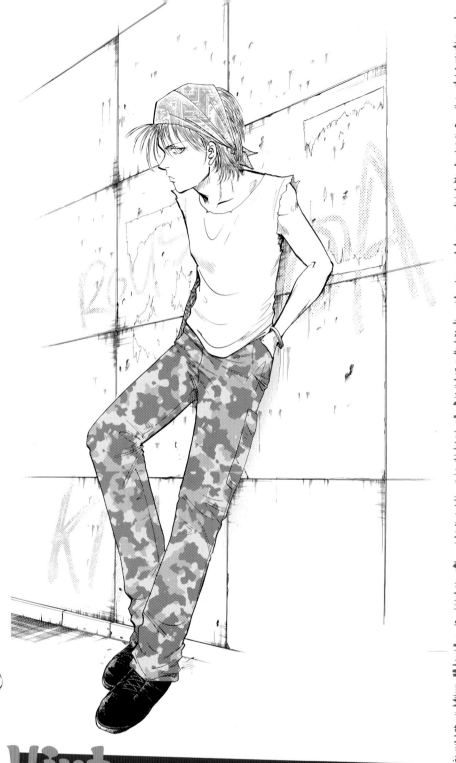

Every action story has its share of bad guys. This punk character could easily be the leader of a criminal enterprise. His expression is watchful, as if he's surveying the streets. The jaggedly cut-off shirtsleeves give him an antisocial look. Plus, that do-rag lets us know that he's not, say, an accountant!

Neck lines go down into body

Long sweeping arch from top to bottom of figure

Curved posture causes folds to appear

Weight-bearing leg is straight

Hint

Notice how the base of the neck is drawn inside the body's outlines. Beginning artists often plop the neck on top of the body. That's a no-no.

96

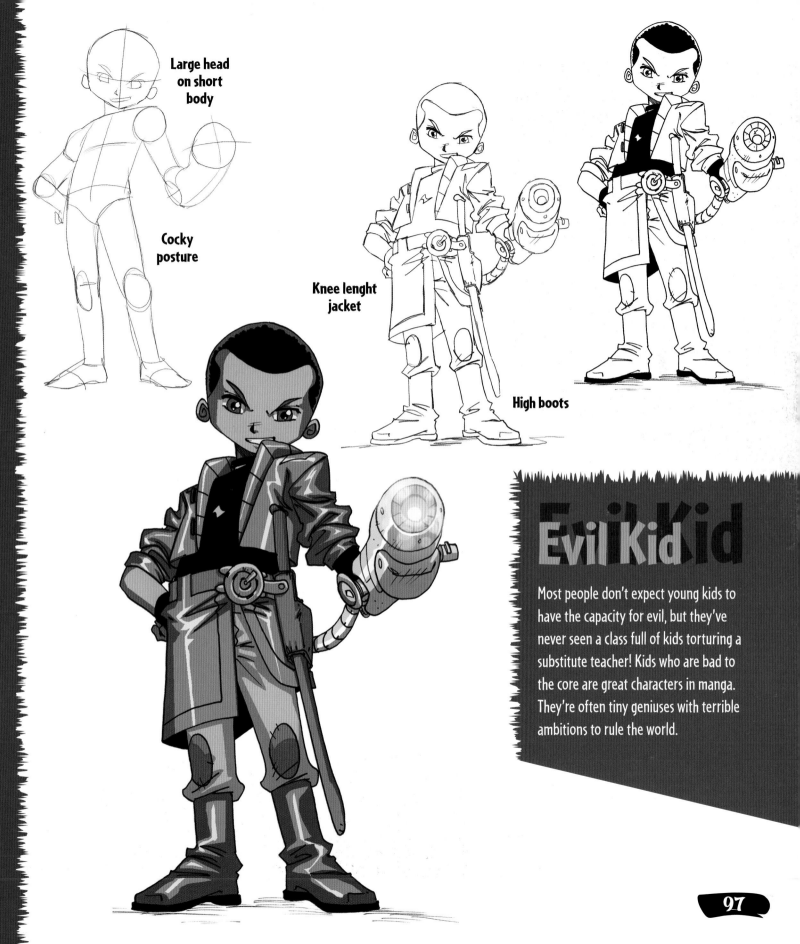

Large head on short body

Cocky posture

Knee lenght jacket

High boots

Evil Kid

Most people don't expect young kids to have the capacity for evil, but they've never seen a class full of kids torturing a substitute teacher! Kids who are bad to the core are great characters in manga. They're often tiny geniuses with terrible ambitions to rule the world.

97

Yakuza
Yakuza

The Yakuza is the organized crime gang of Japan. It's put to good use in many manga stories as the natural enemy of the good guy. Of course, you can easily portray lower members of the Yakuza as thugs with guns and motorcycles, but readers enjoy it when you come up with something fresh, too. Why not go higher up in the organization, where the real power brokers are? For example, this guy could be a top Yakuza who has made a deal to sell top-secret military technology to a rogue nation for a billion U.S. dollars.

It's more effective to give white-collar bad guys expressionless faces than to make them wild-eyed.

Weight-bearing leg

Collar wraps around neck

Arm pulled down straight from weight of attaché case

Make the attaché case three-dimensional

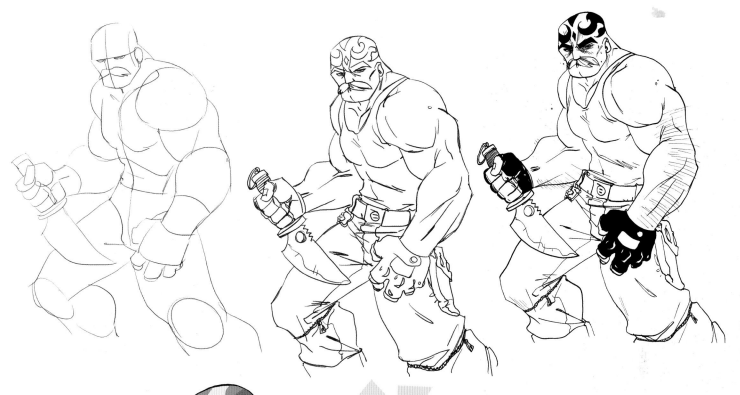

A tank top is always a good choice for a character on the margins of society.

Knife Fighter

Here's a good tip for you: Never get into an argument with a bald guy who has a tattoo on his scalp. Trust me, it's just not a good idea. Another thing: No one has yet figured out why bad guys like to wear cycling gloves. How often do you see a bad guy riding a bicycle? But hey, it looks good, so give it a try!

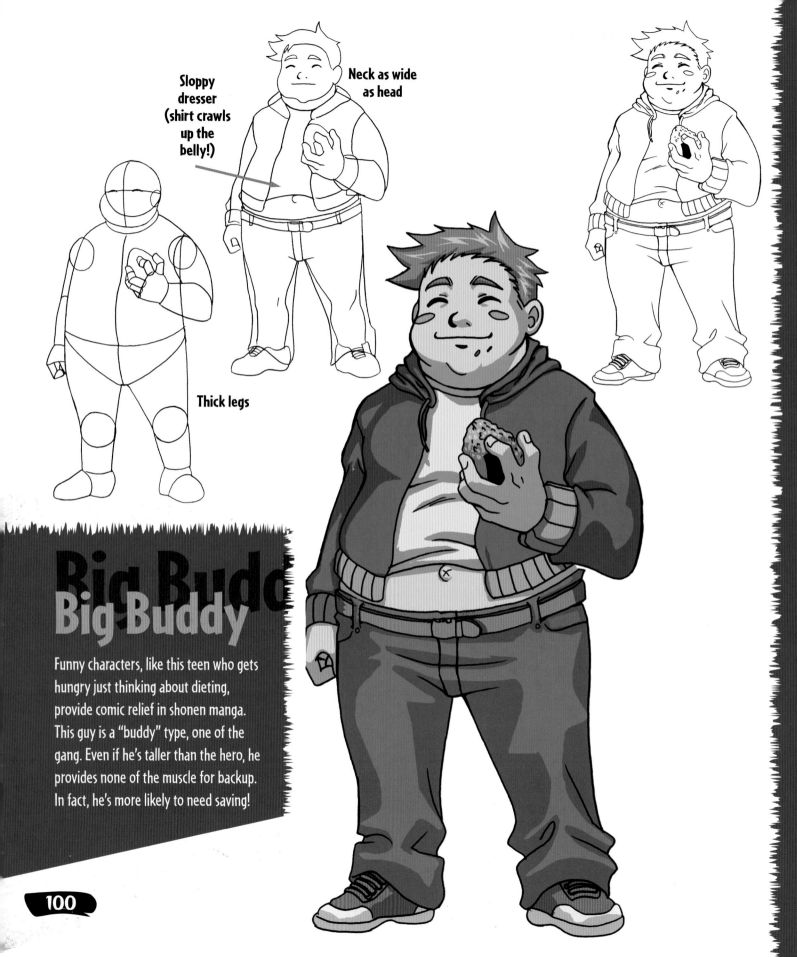

Sloppy dresser (shirt crawls up the belly!)

Neck as wide as head

Thick legs

Big Buddy

Funny characters, like this teen who gets hungry just thinking about dieting, provide comic relief in shonen manga. This guy is a "buddy" type, one of the gang. Even if he's taller than the hero, he provides none of the muscle for backup. In fact, he's more likely to need saving!

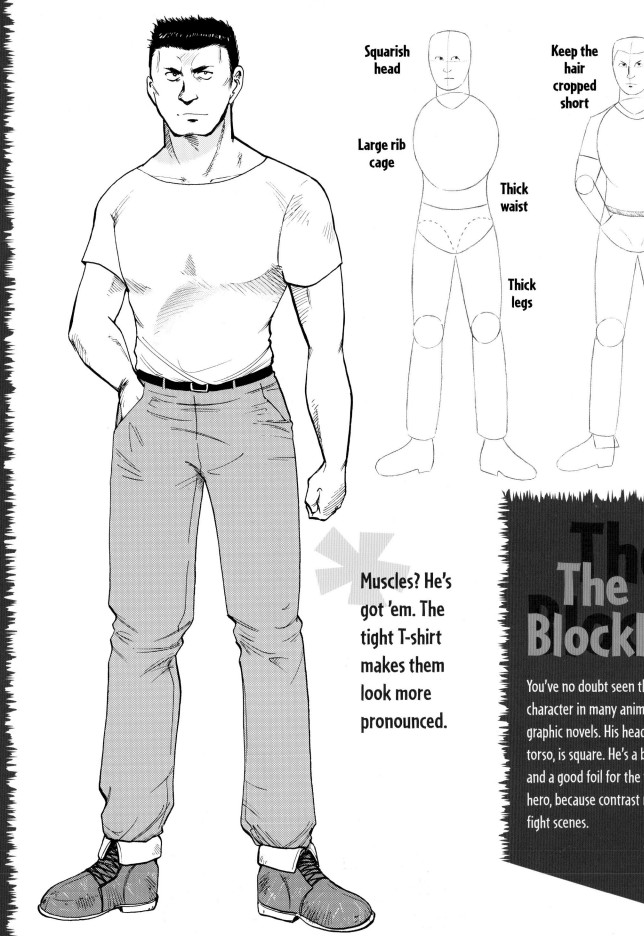

Squarish head

Large rib cage

Thick waist

Thick legs

Keep the hair cropped short

Muscles? He's got 'em. The tight T-shirt makes them look more pronounced.

The Blockhead

The
The
Blockhea

You've no doubt seen this intimidating character in many anime TV shows and graphic novels. His head, as well as his torso, is square. He's a big tough guy and a good foil for the young teen hero, because contrast makes for great fight scenes.

Motorcycle Rider

When drawing a motorcycle, the most important thing to keep in mind is that, except in a perfect side view, the wheels look like ovals, not circles. This is caused by perspective.

Second thing to notice: The rider never sits up straight. If you want your rider to look like he's tearing up the pavement—and who wouldn't?—lean him forward and blow back his hair! To give him that intense look, draw his eyes looking up from under heavy eyebrows.

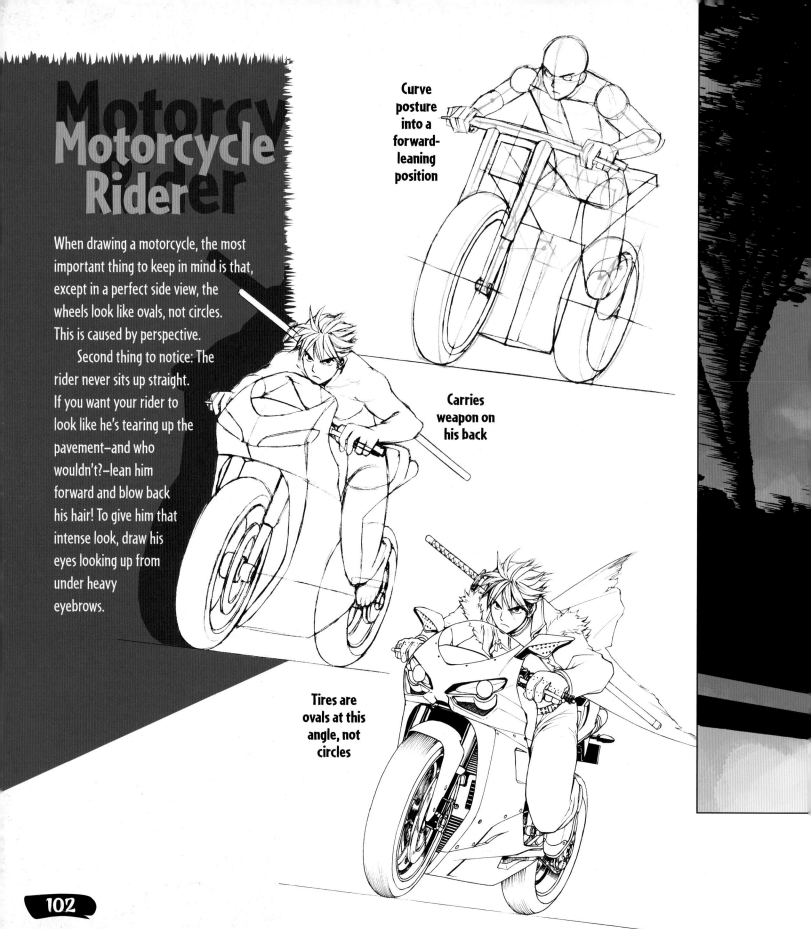

Curve posture into a forward-leaning position

Carries weapon on his back

Tires are ovals at this angle, not circles

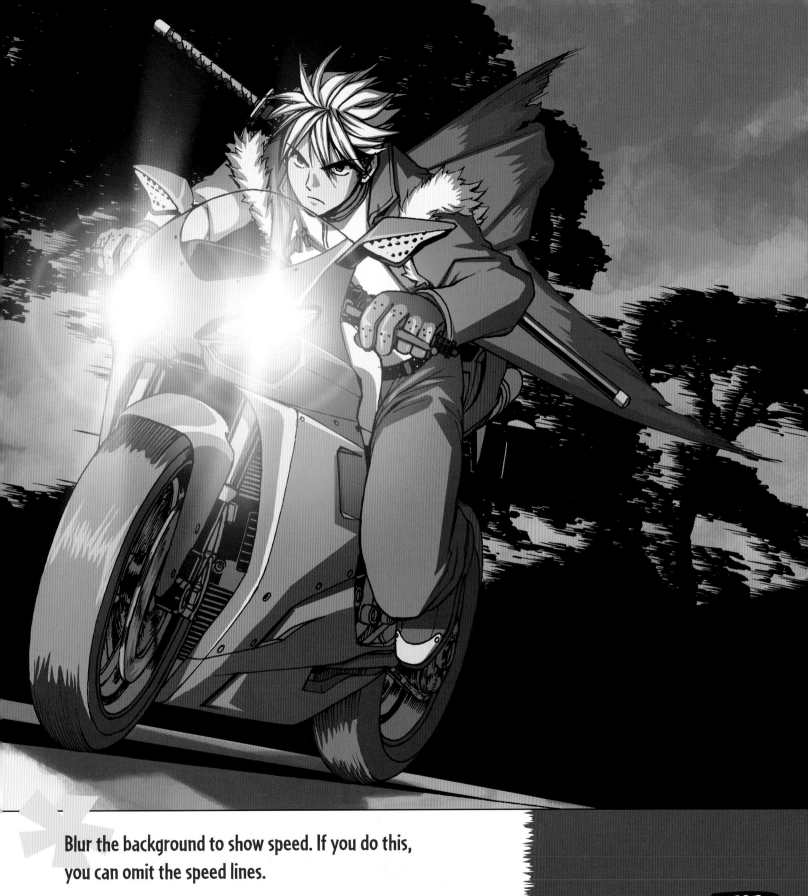

Blur the background to show speed. If you do this,
you can omit the speed lines.

The Cursed Hand

A great addition to any sleek and sinister bishie is an arm that has been cursed by powers of evil. Is it a mecha arm? No, because that skull on his upper arm tells you that he's cursed, not part mechanical, but a character of the dark.

Long, flowing hair

Arm held out at side, as if it has a life of its own!

Dramatic variation on a trench coat

Extra-long legs

Bishies (idealized males) like this guy are sleek and slender.

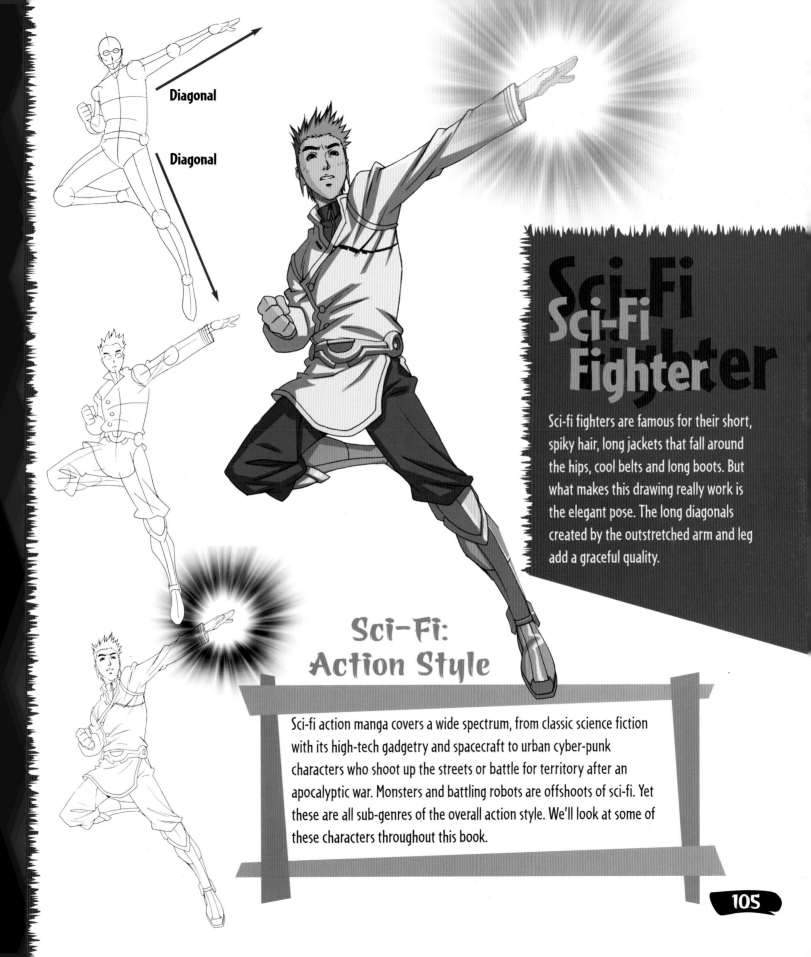

Diagonal

Diagonal

Sci-Fi Fighter

Sci-Fi

Sci-fi fighters are famous for their short, spiky hair, long jackets that fall around the hips, cool belts and long boots. But what makes this drawing really work is the elegant pose. The long diagonals created by the outstretched arm and leg add a graceful quality.

Sci-Fi: Action Style

Sci-fi action manga covers a wide spectrum, from classic science fiction with its high-tech gadgetry and spacecraft to urban cyber-punk characters who shoot up the streets or battle for territory after an apocalyptic war. Monsters and battling robots are offshoots of sci-fi. Yet these are all sub-genres of the overall action style. We'll look at some of these characters throughout this book.

Costume

Costume
Makes the
Character

Creating a new character is sometimes just a matter of choosing the appropriate costume. Take an ordinary fighter kid, dress him in futuristic or fantasy gear, and he'll take on a completely new look. In fact, if you're looking to create a new character, why not see if you can mine your old ones first? Simply take some of your favorite old drawings and recostume them.

Regular
Kid

Fantasy
Fighter

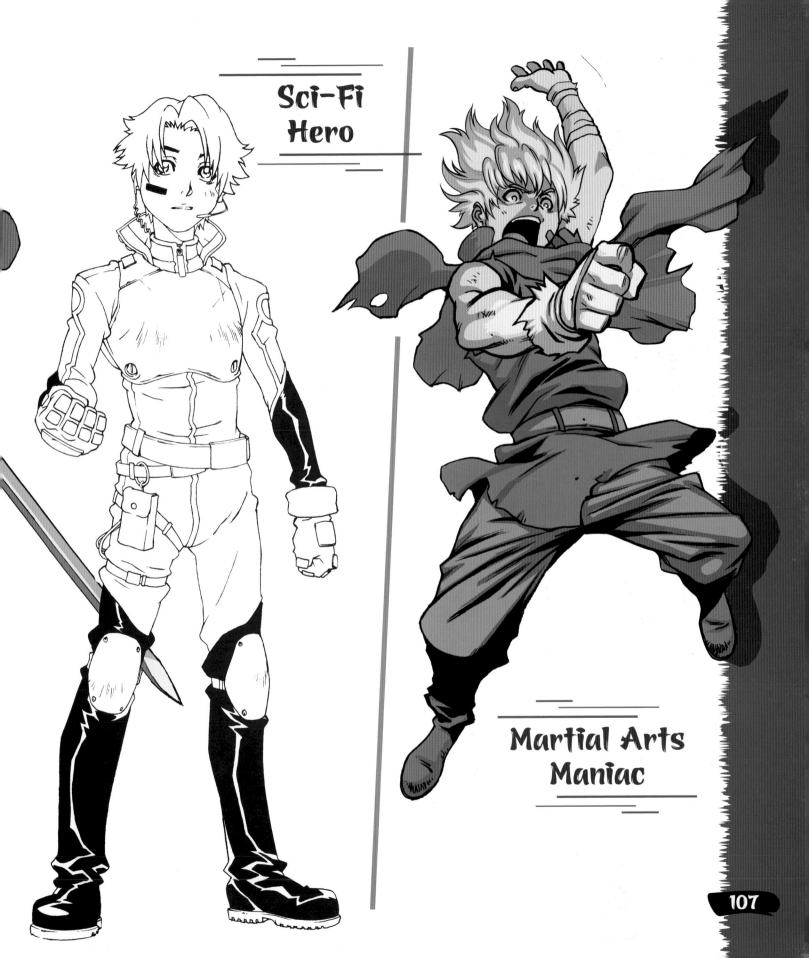

Sci-Fi
Hero

Martial Arts
Maniac

The Dramatic Trench Coat

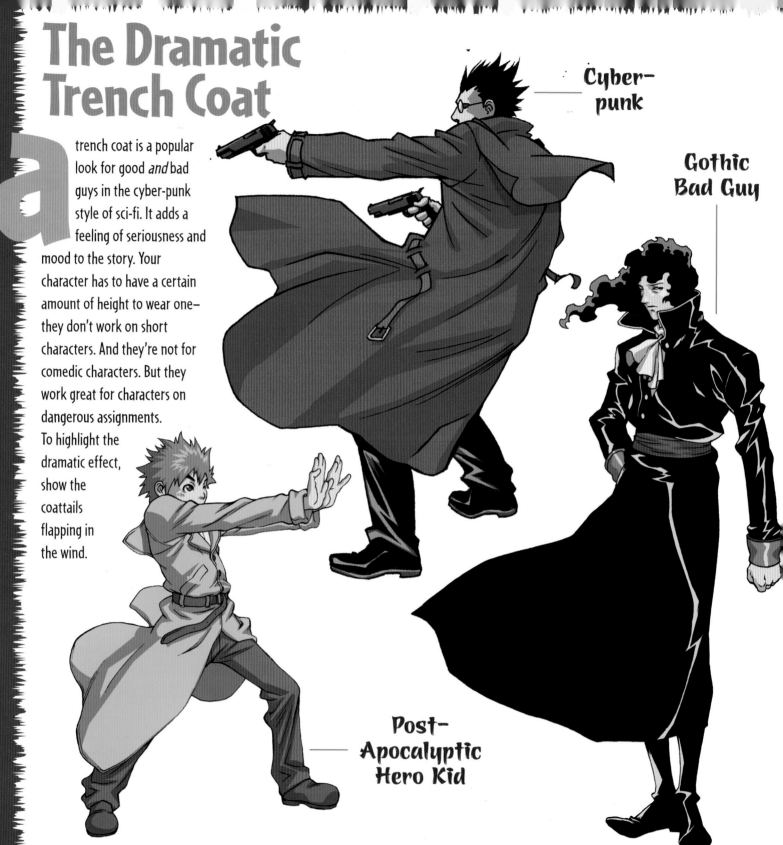

a trench coat is a popular look for good *and* bad guys in the cyber-punk style of sci-fi. It adds a feeling of seriousness and mood to the story. Your character has to have a certain amount of height to wear one—they don't work on short characters. And they're not for comedic characters. But they work great for characters on dangerous assignments. To highlight the dramatic effect, show the coattails flapping in the wind.

Cyber-punk

Gothic Bad Guy

Post-Apocalyptic Hero Kid

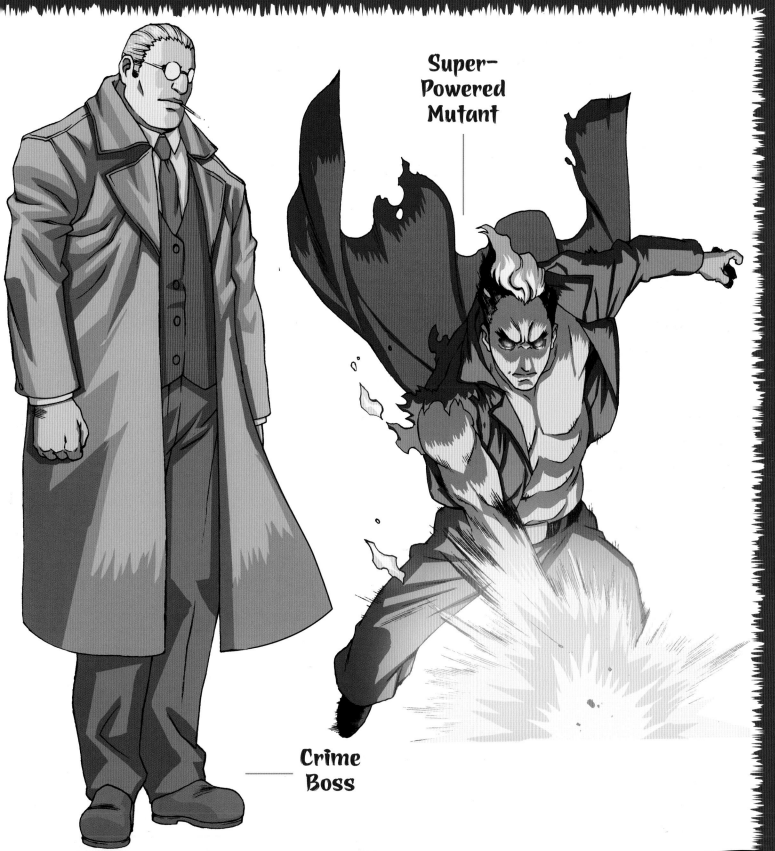

Super-
Powered
Mutant

Crime
Boss

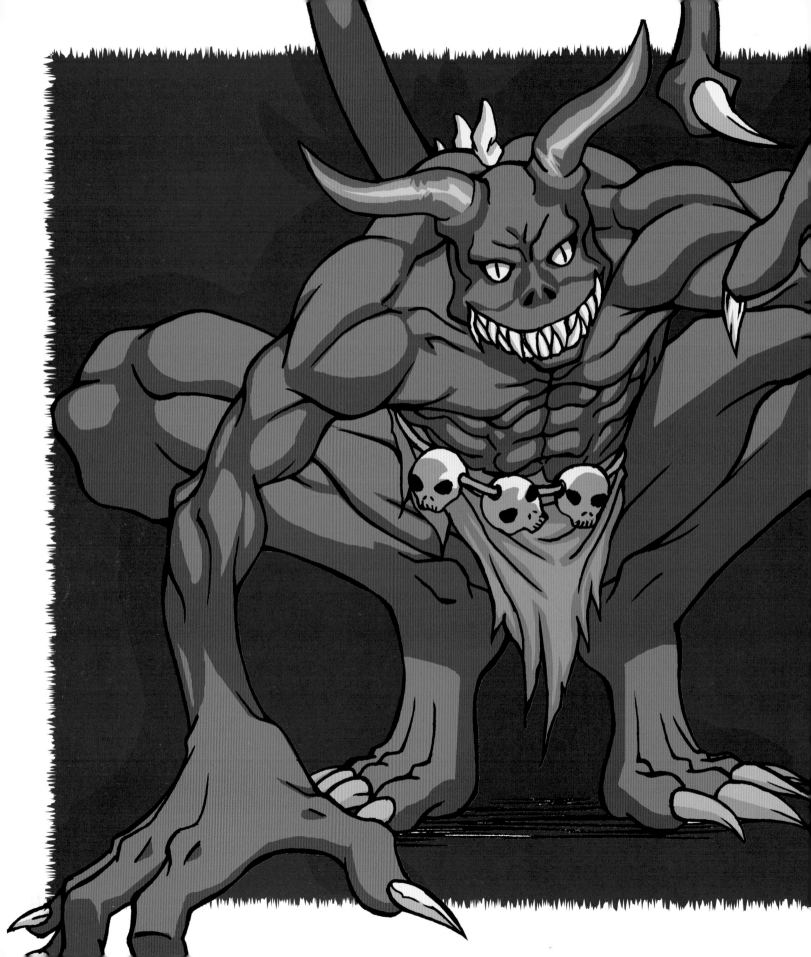

Monsters and Creepy Creatures

the monsters of shonen-style manga are a strange and fearsome crew of creatures. With instincts directed toward maximum destruction, they cause the faint of heart to turn tail and run. Only the brave or foolish remain to do battle. The character designs of the beastly villains are deviously inventive, setting the scene for an epic fight. Luckily for you, we're just going to draw these fiends. Are you ready?

Rock Monster

Jagged spikes shoot up from his shoulders, back and head, and the rippling definition lines of his muscles look craggy, like the edges of a rock. But beneath the exterior shell, the body outline (see the first drawing) is the same as that of any brute-like character, with two notable exceptions: the immense, oversized fists and the lower legs that widen into solid feet.

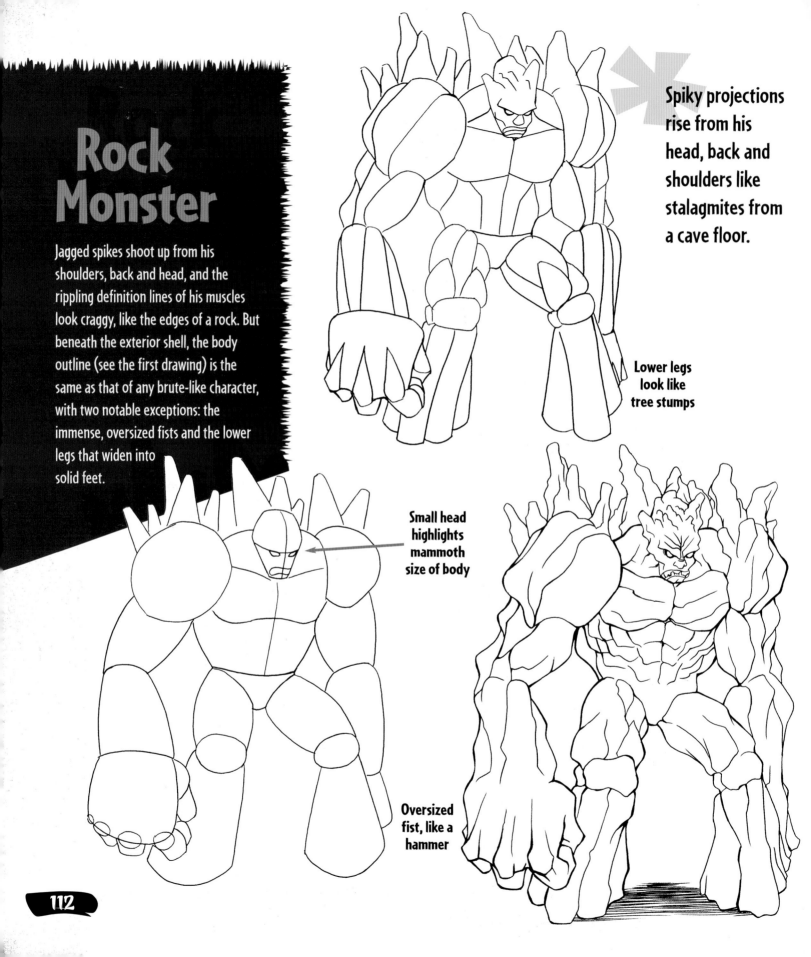

Spiky projections rise from his head, back and shoulders like stalagmites from a cave floor.

Lower legs look like tree stumps

Small head highlights mammoth size of body

Oversized fist, like a hammer

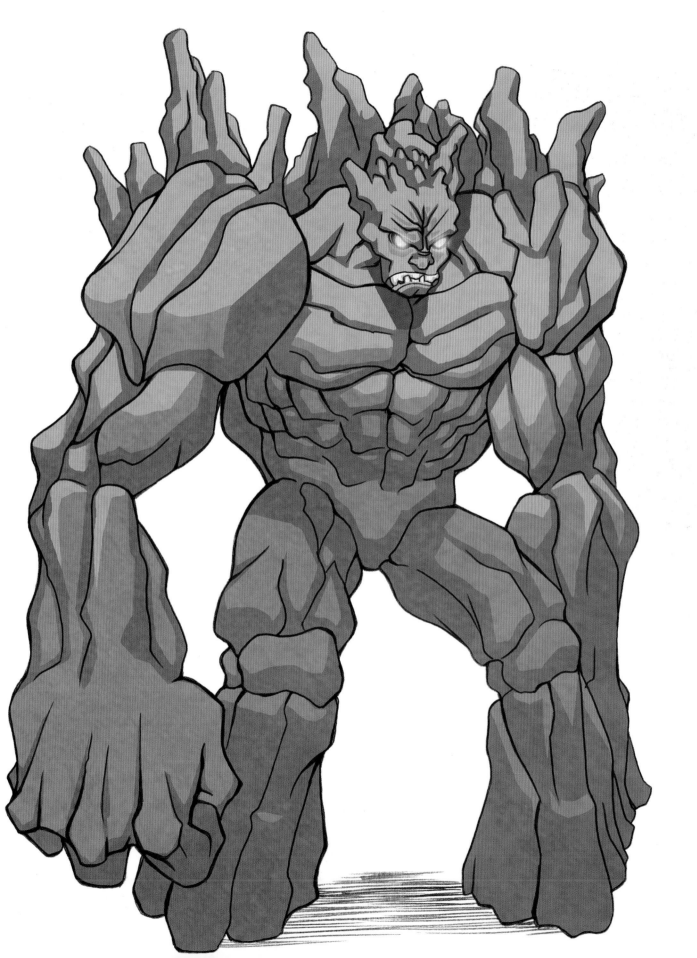

Devil Creature

Horns, claws, sharp teeth and skull accessories are the things that distinguish demon-style monsters. Visual clues like extra-large feet signal to the reader that this character is a beast. Note the slit-like, predatory pupils.

The spike in the tail is not for scratching its back!

Bovine-type horns point out instead of straight up

Hands enlarged due to forced perspective

Rests on balls of feet, with heels pointed toward sky

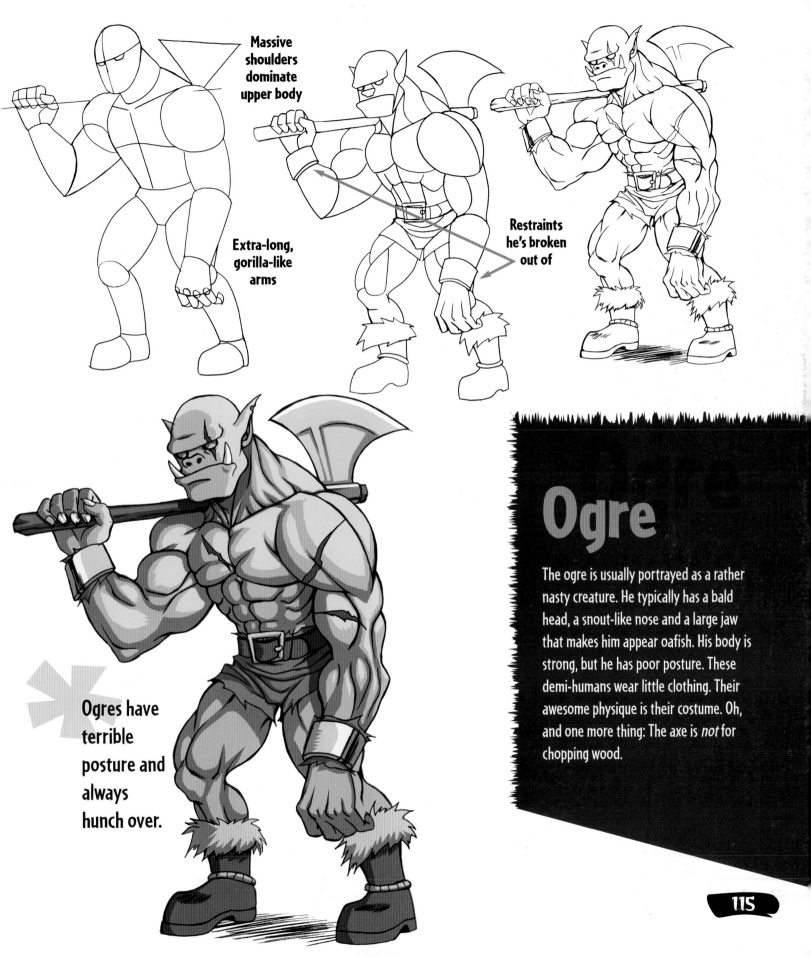

Massive shoulders dominate upper body

Extra-long, gorilla-like arms

Restraints he's broken out of

Ogres have terrible posture and always hunch over.

Ogre

The ogre is usually portrayed as a rather nasty creature. He typically has a bald head, a snout-like nose and a large jaw that makes him appear oafish. His body is strong, but he has poor posture. These demi-humans wear little clothing. Their awesome physique is their costume. Oh, and one more thing: The axe is *not* for chopping wood.

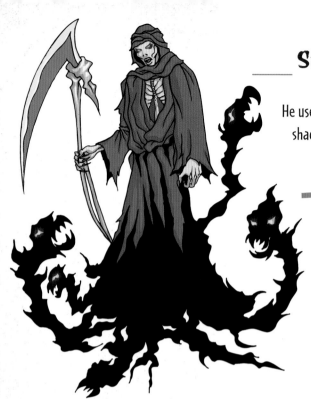

Summoning Demons

He uses his powers to conjure shadowy demons that do his dark bidding.

Generating Force Fields

This evil being wields a magical staff that harnesses electrical energy he uses to strike down his enemies.

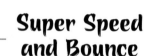

Monsters With Special Powers

We've got some pretty compelling heroes and heroines in this book, and if our evil characters are going to go toe to toe with them, they'll have to do more than stand around looking wicked. Special powers make evil characters seem more threatening. And they're fun to draw, too.

Super Speed and Bounce

This strange creature bounds from perch to perch leaving speed lines in its wake.

Capturing Prey

Multiple tongues make it easy to ensnare unsuspecting prey.

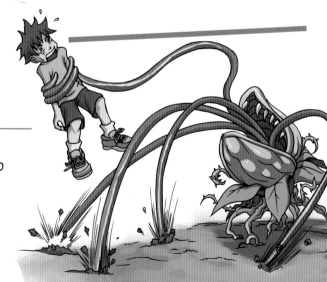

Underwater Abilities

Some mutants can swim and breathe underwater as well as on land.

Breathing Fire

This dragon's fiery breath begins as a narrow stream of fire, then bursts at the end.

Shape Shifting

This pint-sized villain morphs from a ghost into a boy.

Super Strength

This guy's huge mechanical arm is programmed to deliver maximum power.

Monster Fighter!

This is the ultimate showdown—a battle between boy and beast. Summoning the spirits of his ancestors, who were great fighters, the boy is imbued with powers far beyond his normal abilities. His razor-sharp karate punch pulverizes the rock with such an explosive force that the monster evaporates.

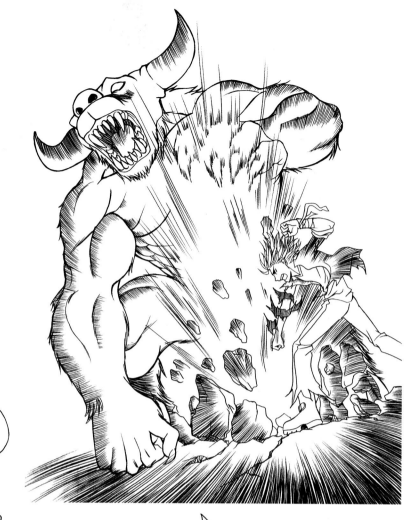

Hint

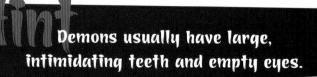

Demons usually have large, intimidating teeth and empty eyes.

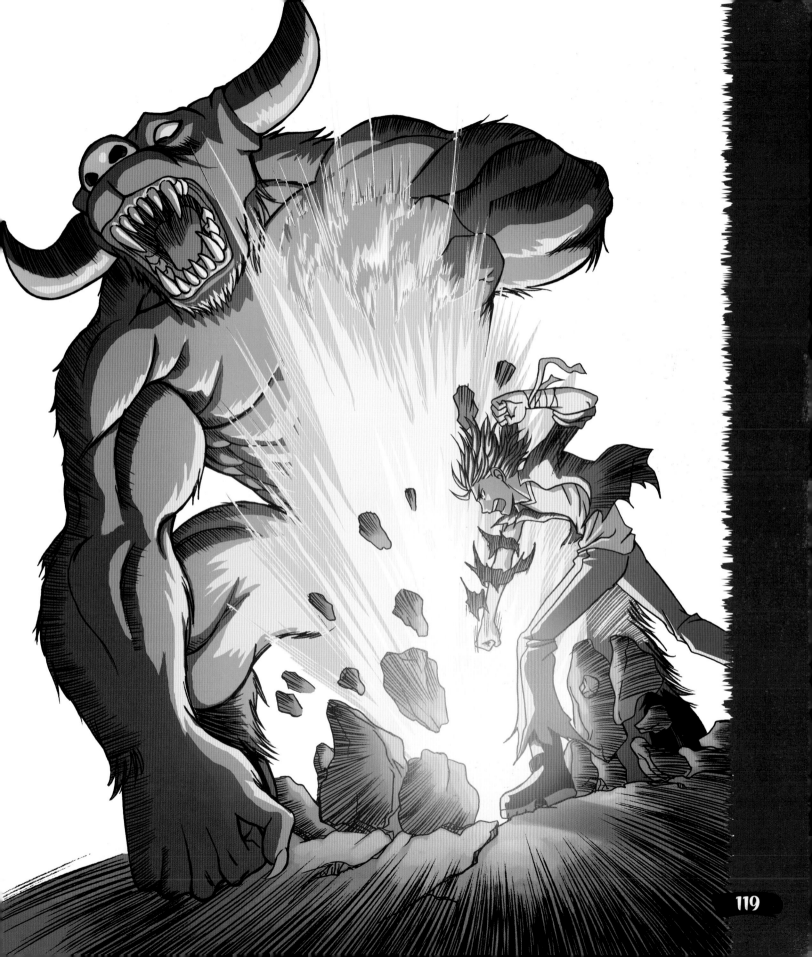

Animal-Based Spirits and Demons

n many graphic novels and anime shows, the hero has been cursed. The curse can take many forms, but often an animal demon latches onto the hero, and he or she is doomed to carry the burden of evil forever. The accursed person can often transform back and forth from magical animal to human, such as when super strength and powers are needed. Here are some of the most popular types of creatures that are used for animal legends.

Tiger Girl

Notice how flames arise from the tiger's stripes. In addition, the tiger represents a style of Shaolin Kung-Fu, so it's a perfect match for this skilled fighter.

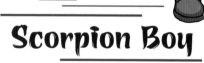

Scorpion Boy

How do we know this boy is evil? Because the scorpion is a creature we always associate with the forces of darkness. The flames shooting from the scorpion's pincers are mirrored in the boy's hand. In fight scenes, the boy would likely have in reserve an ultimate weapon: a piercing fist that plunges deep into the body, just like the scorpion's stinger.

Wolf Demon

Rather than draw a straight-forward wolf, heighten its evil appearance by giving it a lionesque mane (echoed in the boy's shaggy do) and unusual black markings. But what really marks it as a malevolent beast are the empty, almond-shaped eyes.

Bear Spirit

Energy beams, like the ones emanating from this bear, create a fantasy look. Notice how the posture of the boy mimics that of the animal from which he gains his strength. This is an important detail.

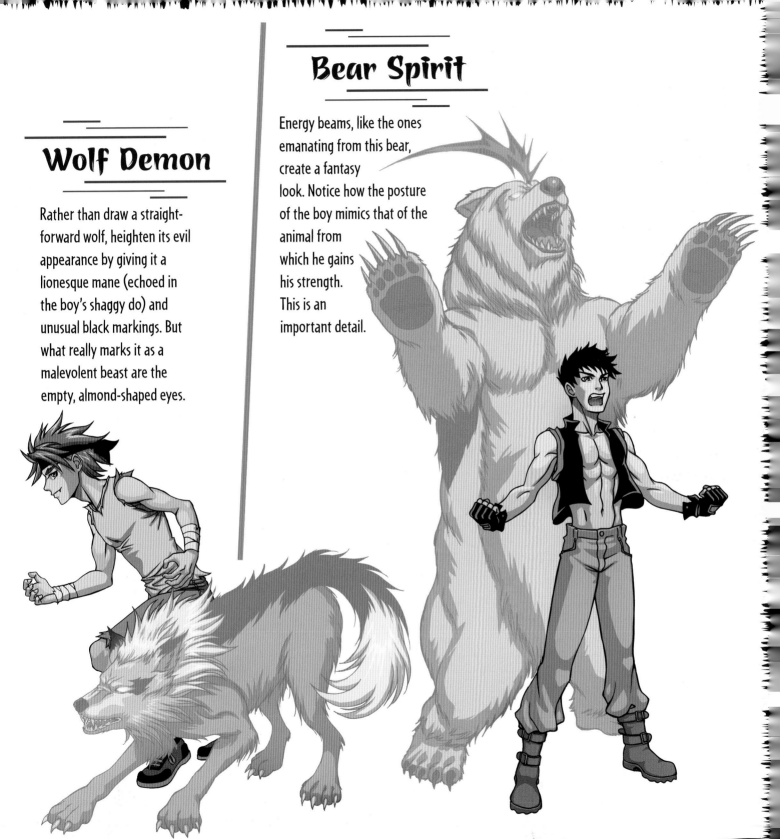

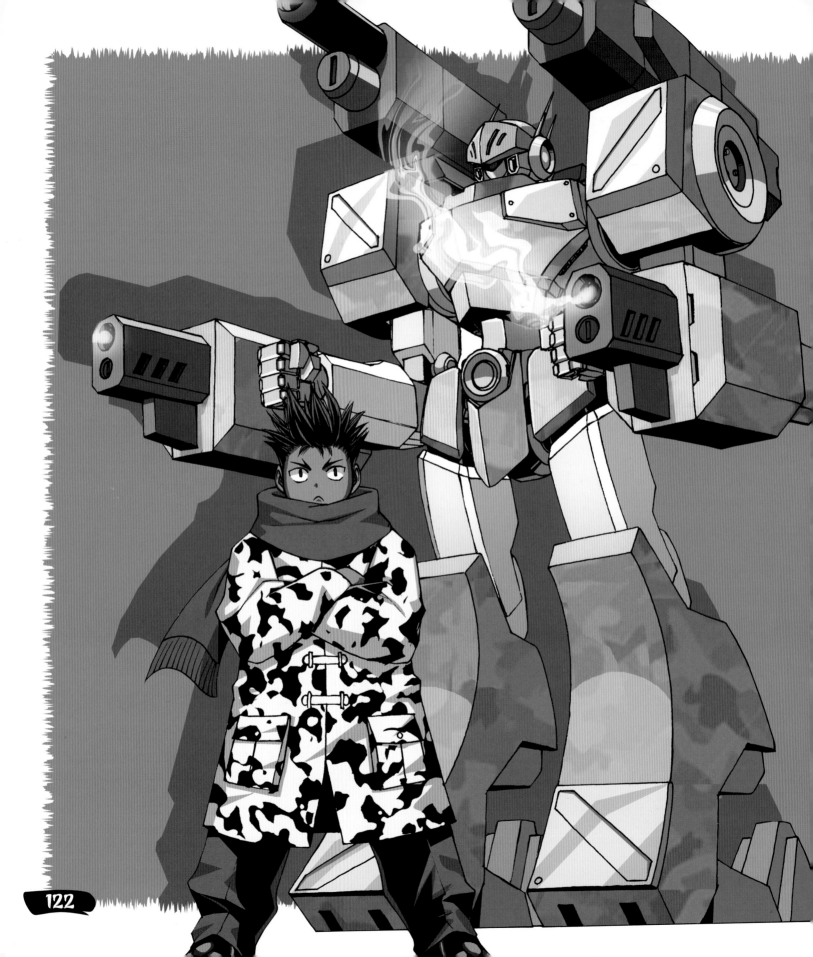

Battle-Ready Robots

If you like futuristic weaponry and heavy-duty action, you're going to love this chapter. It's packed full of fearsome fighting machines, from colossal robots as big as buildings to smaller ones that pair up with humans. In Japan, there are artists who draw robots exclusively and are as skilled as architects, but you don't have to go to that extreme to draw yours effectively. In fact, this chapter will show you how to draw state-of-the-art robots no matter what your level of ability.

Drawing the Robot's Head

Drawing the Robot's Head

Before we draw the entire robot, let's start off gradually by doing a close-up of the head.

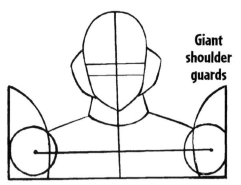

Giant shoulder guards

Form-fiting helmet

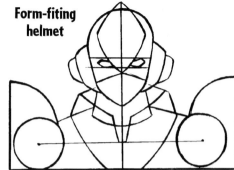

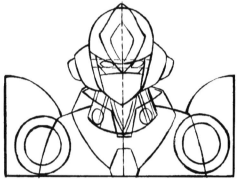

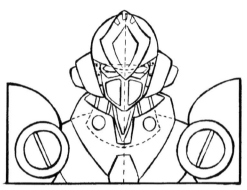

Many giant robots wear helmets and face guards that give them an emotionless expression. This makes them look programmed, and determined, to destroy.

Front View

Because a robot is a mechanical device, it should be perfectly symmetrical in the front view—both sides have to align evenly with each other. This doesn't mean you have to actually measure the robot, but be sure to eyeball it carefully.

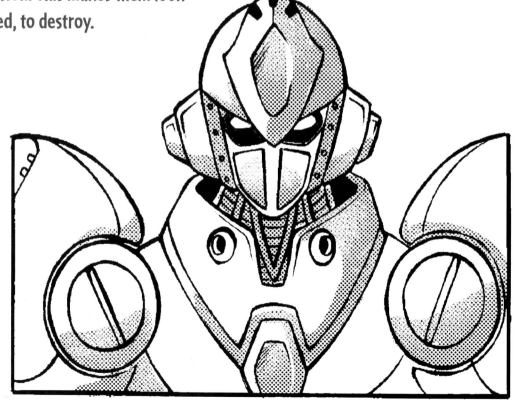

Profile

The side view of the head begins with an egg shape, the same as on a human. But instead of adding features to it, add a protective visor and hardware. And while you should draw eye sockets, do not give the robot eyeballs. It's much eerier if the sockets are left empty!

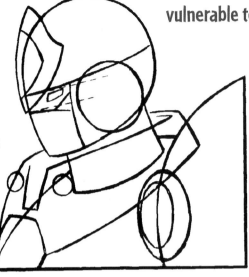

The collar is large and surrounds the neck, which would otherwise be vulnerable to attack.

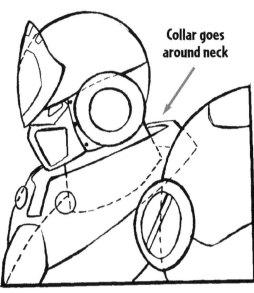

Collar goes around neck

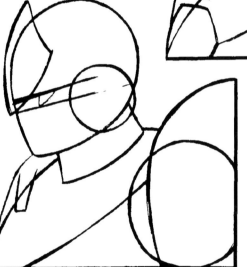

Immense shoulders dwarf head

Thin (vulnerable) neck

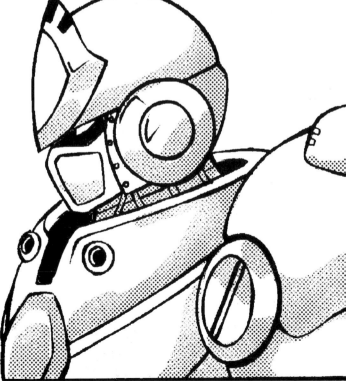

Round-T
Round-Type Robot

Giant robots are built primarily in one of two ways: from box shapes or from round shapes (or cylinders). Let's start off with a round-shaped robot, because it's somewhat easier to draw.

Basic figure is built like a human brute

Front View

Your first impression of the final robot might be that it looks challenging to draw, but if you look at it step by step, you'll see that it's actually not that complicated. Start off with the basic figure and then add armor to it to give it a mechanical look.

Note how immensely wide this robot is: His shoulders are spread far apart, giving him a super-broad appearance.

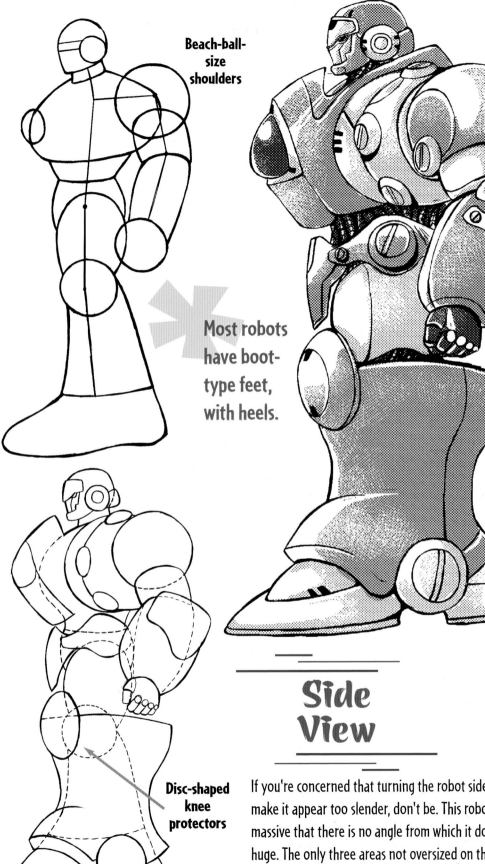

Beach-ball-size shoulders

Most robots have boot-type feet, with heels.

Disc-shaped knee protectors

Side View

If you're concerned that turning the robot sideways will make it appear too slender, don't be. This robot is so massive that there is no angle from which it doesn't look huge. The only three areas not oversized on the giant robot are his hands, head, waistline and neck.

Back to Basics

The trick to drawing a robot is getting the outline right. Don't start defining the gadgets and weapons until the final stages, even if it's tempting (and I know it is!). Once you have the initial figure in place, then you can add details.

You can personalize these robots any way you like. You may want to add your own style of shoulder guards, knee guards and weapons. Or you may decide to omit some parts of the robots, such as the boot heels.

Classic Colossal Robot

Classic Colossal Robot

If it's action you're looking for, it doesn't get much better than this gigantic cylinder-type robot. Robots like this one are many stories tall and are usually commandeered by a human sitting in a cockpit inside their head. Sometimes their limbs are turned into weapons. Many of them also fly with the assistance of jets built into their suits or into their feet.

This robot's shape more closely resembles human anatomy than the other types of giant robots we'll see in the next few pages.

Giant characters like this robot are usually drawn with small heads and large feet.

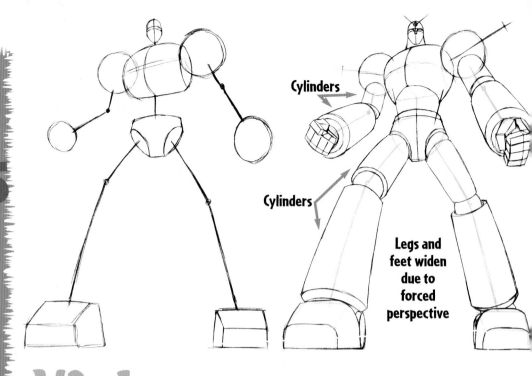

Cylinders

Cylinders

Legs and feet widen due to forced perspective

Hint

When drawing a robot, give it ball-and-socket joints in the same places humans have joints: shoulders, elbows, knees, ankles. The robot must be able to move and walk like a human, albeit a very heavy and cumbersome one.

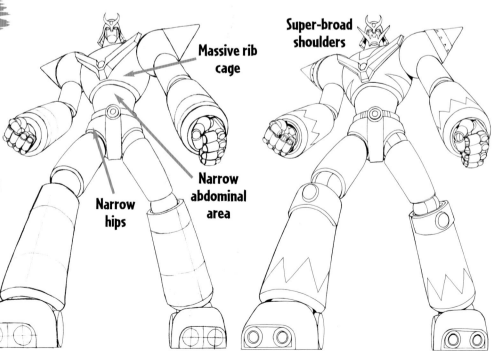

Massive rib cage

Super-broad shoulders

Narrow hips

Narrow abdominal area

Keep It Simple

Rather than add tons of gizmos and technical doodads all over the finished robot—which is an impulse I understand well—put your efforts into creating an attractive pattern on the robot. It's more pleasing, and it helps the reader distinguish one shape from another. And it becomes the robot's signature costume.

The classic robot's limbs are made from cylinders.

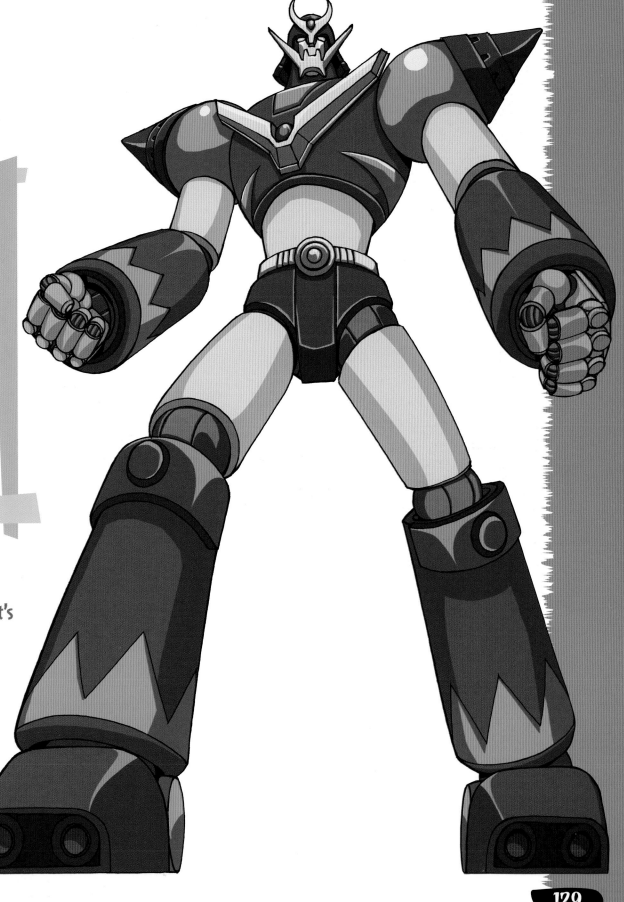

Elegant but Deadly Robot

Elegant but Deadly Robot

This sleek bag of nuts and bolts is elegant, tall, and plenty evil-looking. But don't be fooled by the final image with all the fancy patterns and colors. A closer look at the first few steps will show you that this guy is pretty basic and easy to draw.

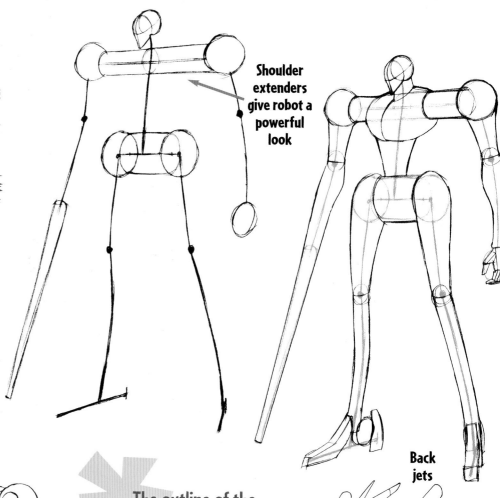

Shoulder extenders give robot a powerful look

Back jets

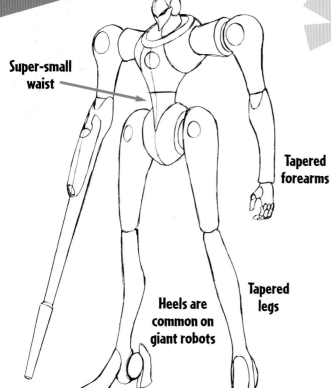

Super-small waist

Tapered forearms

Tapered legs

Heels are common on giant robots

The outline of the head is based on the human head, only much smaller, making the body look gigantic by comparison.

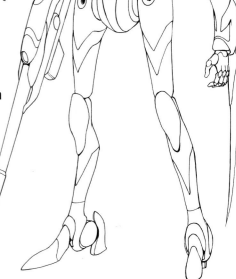

One arm is a laser rifle

Taking It to Extremes

This robot's shoulders are actually wider than its torso is long. *These are extreme proportions.* Notice, too, that the arms and legs are constructed in such a way that it's impossible for them to move close together. This broad stance ensures that every pose will look powerful.

The elegant robot's body is created with slender forms that taper.

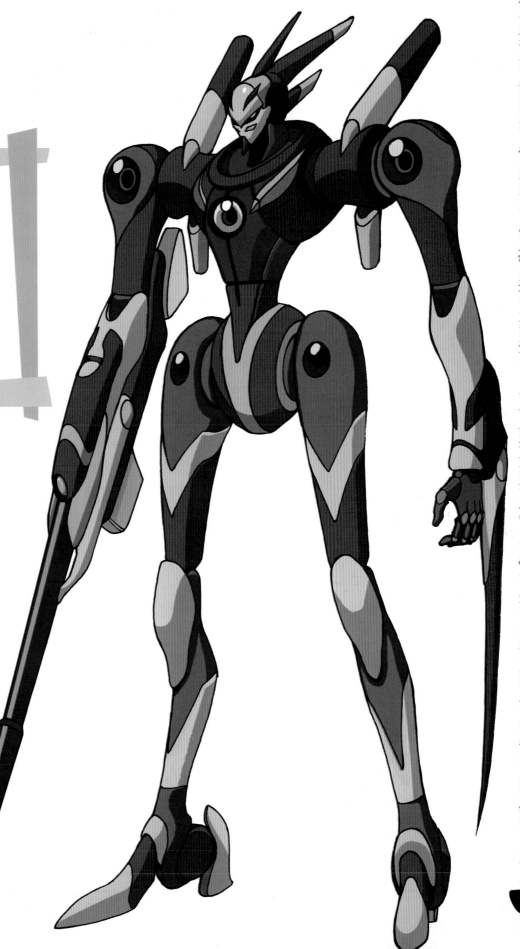

Hyper-Mechanized Robot

Hyper-Mechanized Robot

If you like drawing detailed, technical-looking machines, then this type of robot is for you. Nothing is round; it's a mass of boxy shapes. Every inch of surface area is compartmentalized. Many of these compartments open up, and canons and other devices emerge. This robot should appear to be heavily armored for intense fight scenes.

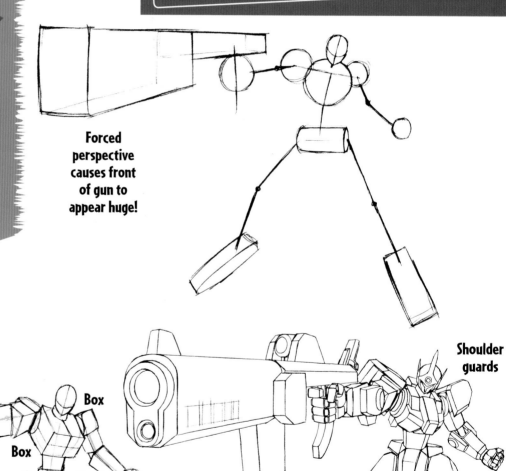

Forced perspective causes front of gun to appear huge!

Box

Box

Box

Box

Shoulder guards

Knee guards

132

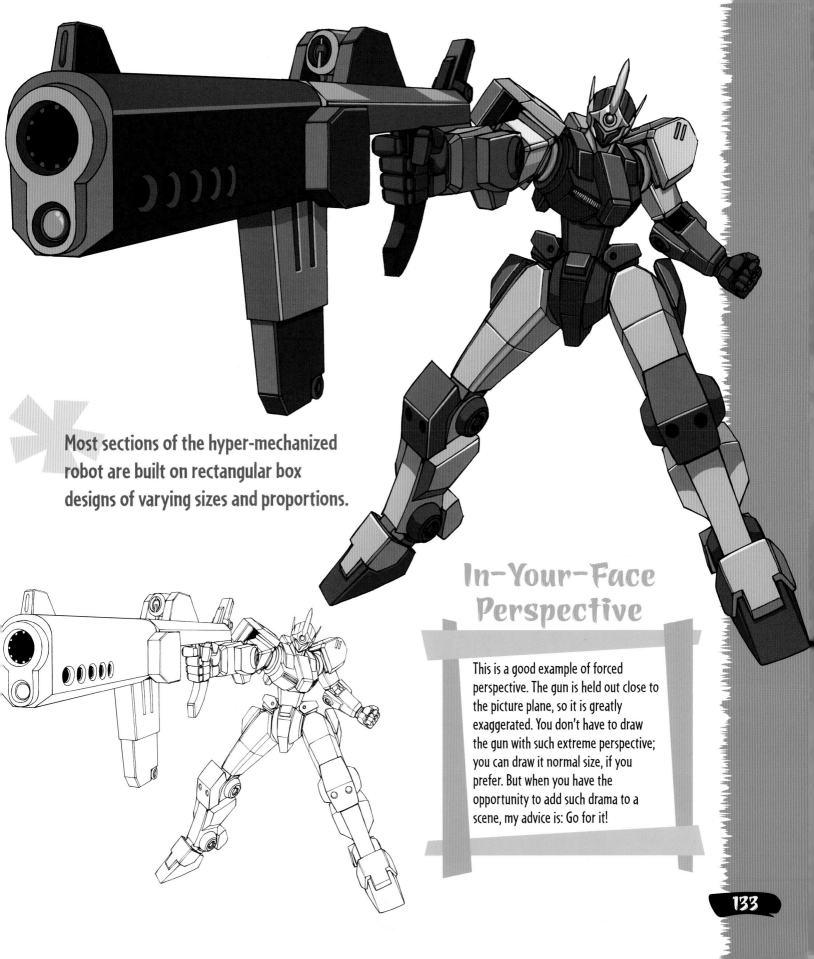

Most sections of the hyper-mechanized robot are built on rectangular box designs of varying sizes and proportions.

In-Your-Face Perspective

This is a good example of forced perspective. The gun is held out close to the picture plane, so it is greatly exaggerated. You don't have to draw the gun with such extreme perspective; you can draw it normal size, if you prefer. But when you have the opportunity to add such drama to a scene, my advice is: Go for it!

133

Robots

Robots and Their Human Pals

and Their Human Pals

Robots come in two varieties: the gargantuan robots we've been drawing so far in this chapter and somewhat smaller, sentient robots who work alongside their human buddies. Here are a few popular human-robot combos.

A Boy and His Robot

This is a standard but V-E-R-Y popular buddy team. The boy is definitely the brains behind the team, although the robot has enormous power as well as special, finely tuned senses, such as super sight, amazing hearing, heat sensors and motion detectors.

Female Robot

The female robot is a cool character, because it's a little eerie. It's not supposed to look like a real girl who happens to be made of metal—that would make it a cyborg. No, this is a huge piece of metal hardware, but with the vague—and I do mean vague—aspects of the female form.

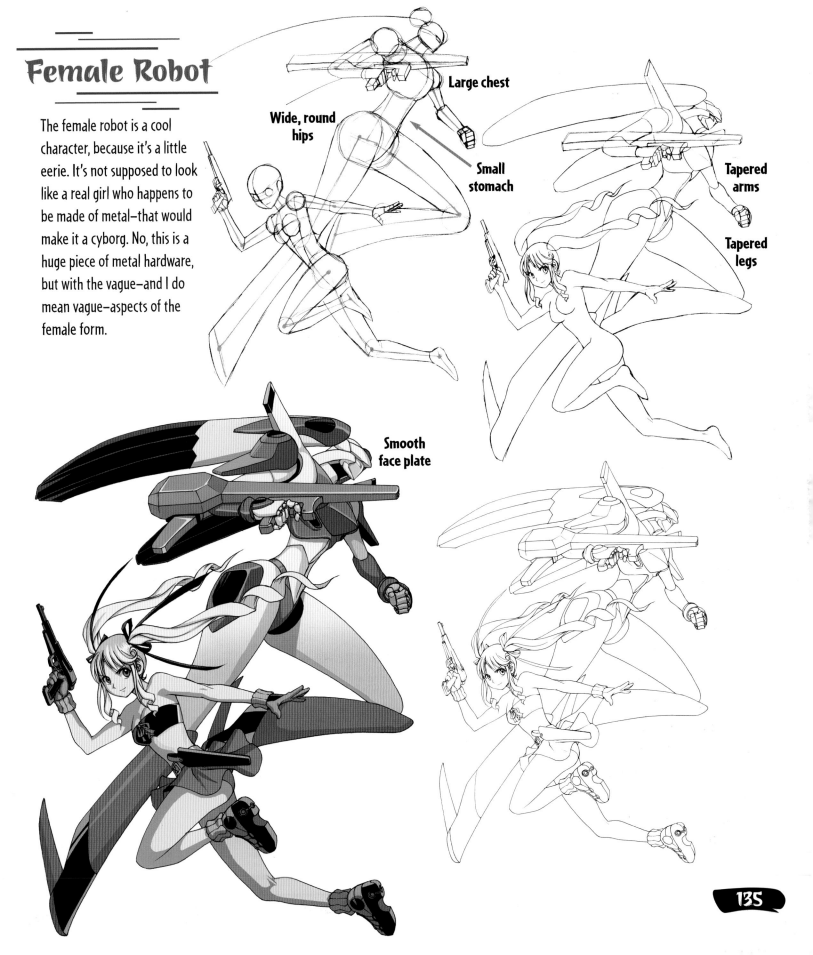

Large chest

Wide, round hips

Small stomach

Tapered arms

Tapered legs

Smooth face plate

Small collar rises up over chin

Hint

To make the robot look especially enormous, sink the head one third of the way down into the chest. The chest will look like a huge fortress.

All-Firepower Robot

This very popular type of robot is a walking weapons system. Canons are mounted on its shoulders, guns on its forearms. Let's see someone pick on this kid now!

This type of robot is very linear in design, with lots of hard angles, squares and rectangles.

136

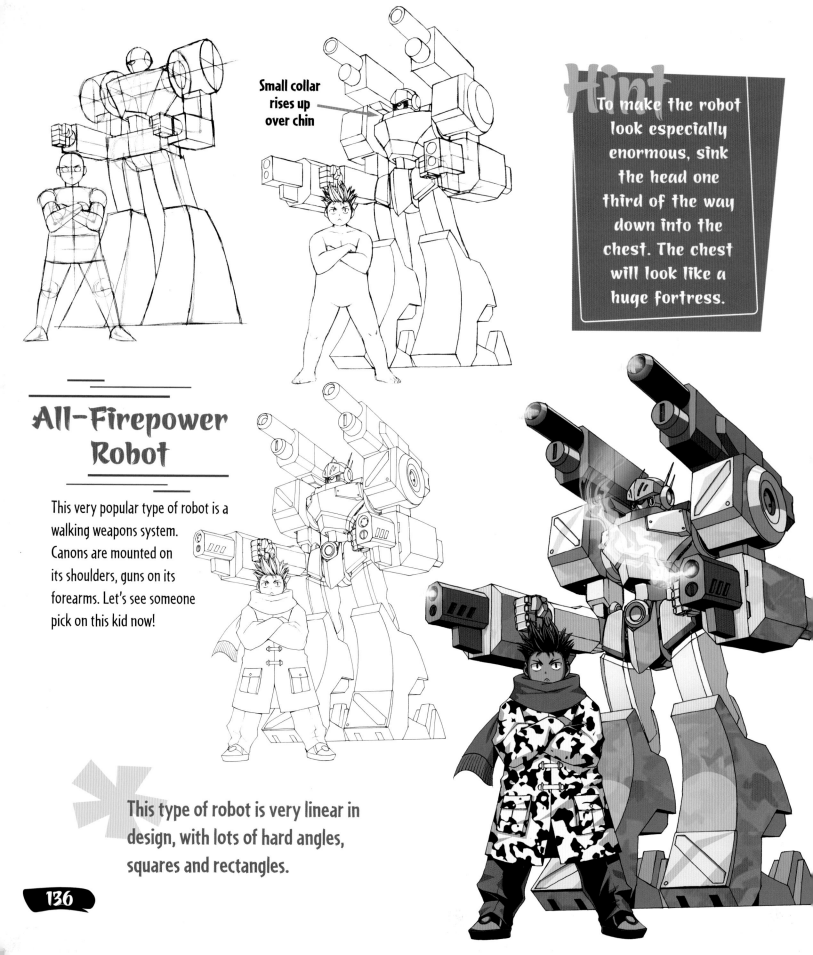

Villainous Robot

Can a robot have a personality? Absolutely! Especially a robot of darkness! This evil machine communicates its bad intentions through its design. It is often skinny and lanky, with sharp fingers and pointy feet. The metal is shaded with large areas of black, giving the robot a brooding, darkly shining intensity.

The torso of this robot is divided into segments for greater flexibilty.

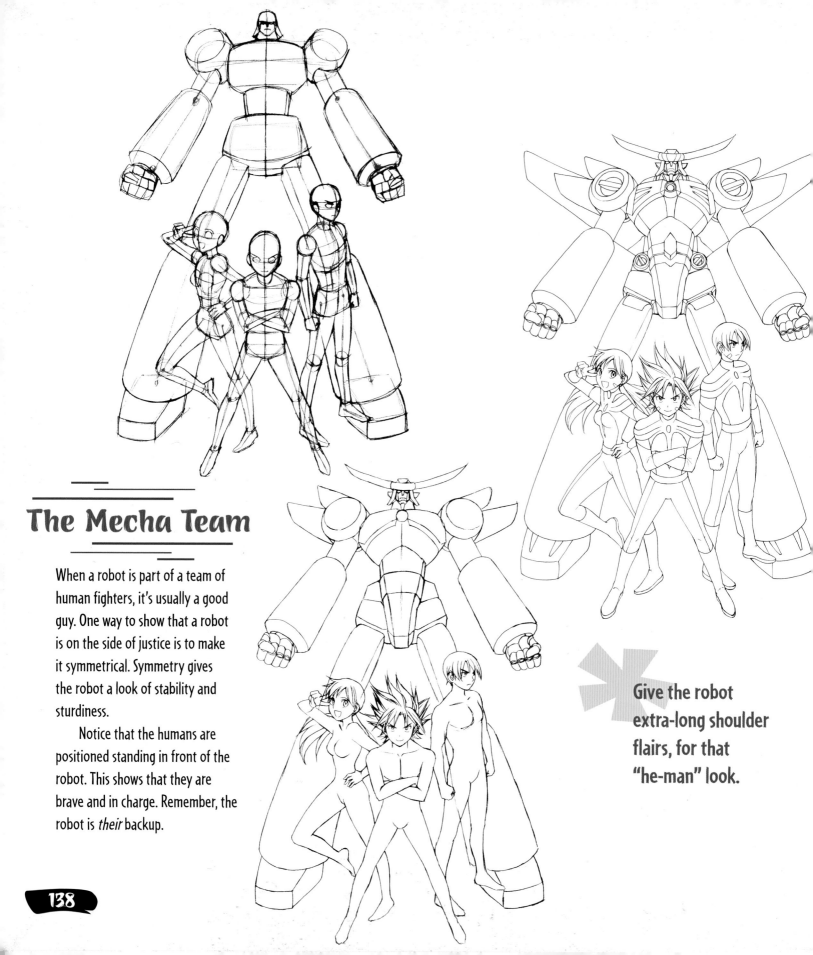

The Mecha Team

When a robot is part of a team of human fighters, it's usually a good guy. One way to show that a robot is on the side of justice is to make it symmetrical. Symmetry gives the robot a look of stability and sturdiness.

Notice that the humans are positioned standing in front of the robot. This shows that they are brave and in charge. Remember, the robot is *their* backup.

Give the robot extra-long shoulder flairs, for that "he-man" look.

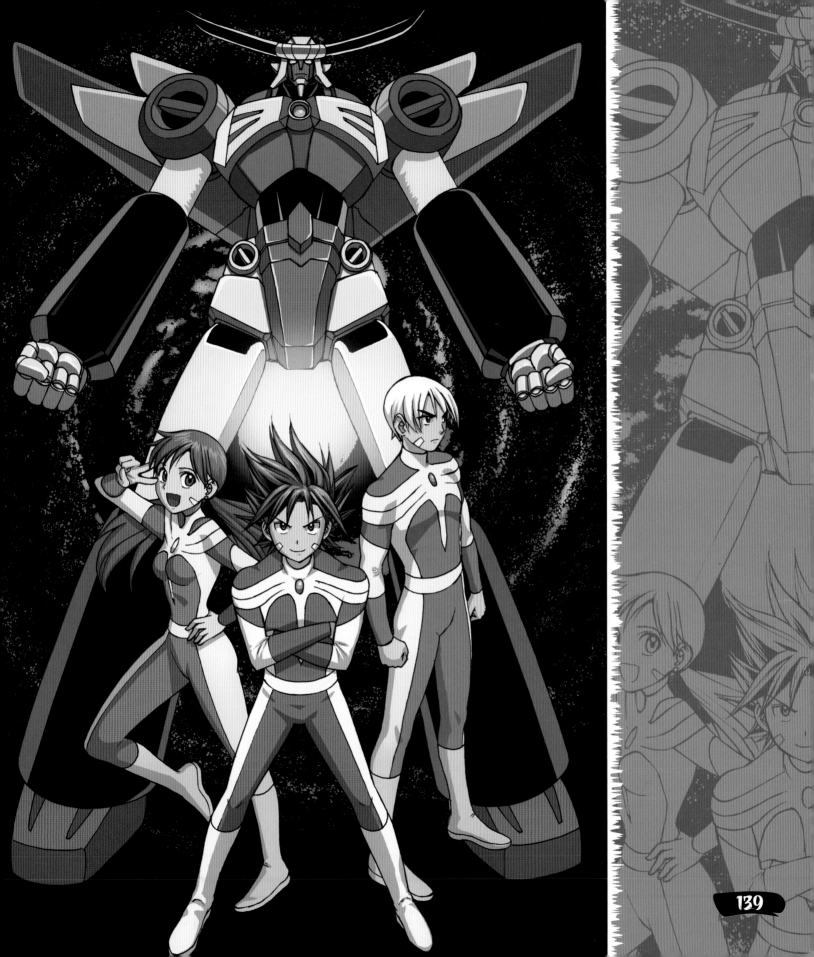

Sketching a Sequential Story

The Story

before we leave the exciting world of shonen manga, let's take one last look at what makes it so compelling—the story! In graphic novels, we see only the finished inks, so I thought it would be useful and interesting to look at how a scene is first interpreted. At this early stage, you make choices about several elements:

✳ Angle of the "shot" (closeup, tilted, long shot, etc.)
✳ Contents of each panel

✳ Size and shape of each panel (vertical, rectangular, oval, etc.)
✳ How one panel flows into the next

In a graphic novel, you tell a story by stringing together a *series* of panels. Sometimes the different angles flow naturally from one into the other. Or you might want to shake up the scene by cutting from one panel to a jarringly different angle. Just remember: The action of the scene dictates the angle and panel shape you use, so don't impose your favorite angles onto a scene without considering the contents.

Here's the setup: The emperor's men, all on horseback, storm into a peaceful village of hardworking peasants who are just getting by on subsistence farming. The emperor's men demand higher taxes. When an elderly woman meekly begs to be spared the heavy burden, she is killed for her insolence. What the emperor's men didn't count on is that there is a *samurai* living among the peasants. And now he's ticked off!

✳ **This story reads from left to right, but many manga graphic novels also read from right to left.**

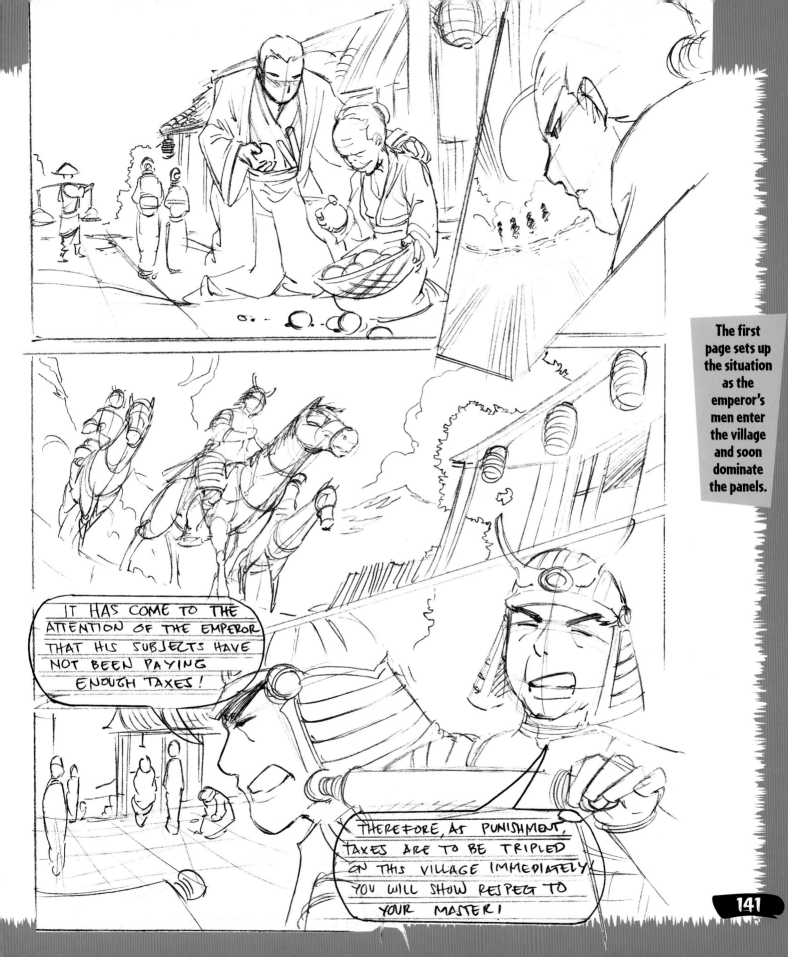

The first page sets up the situation as the emperor's men enter the village and soon dominate the panels.

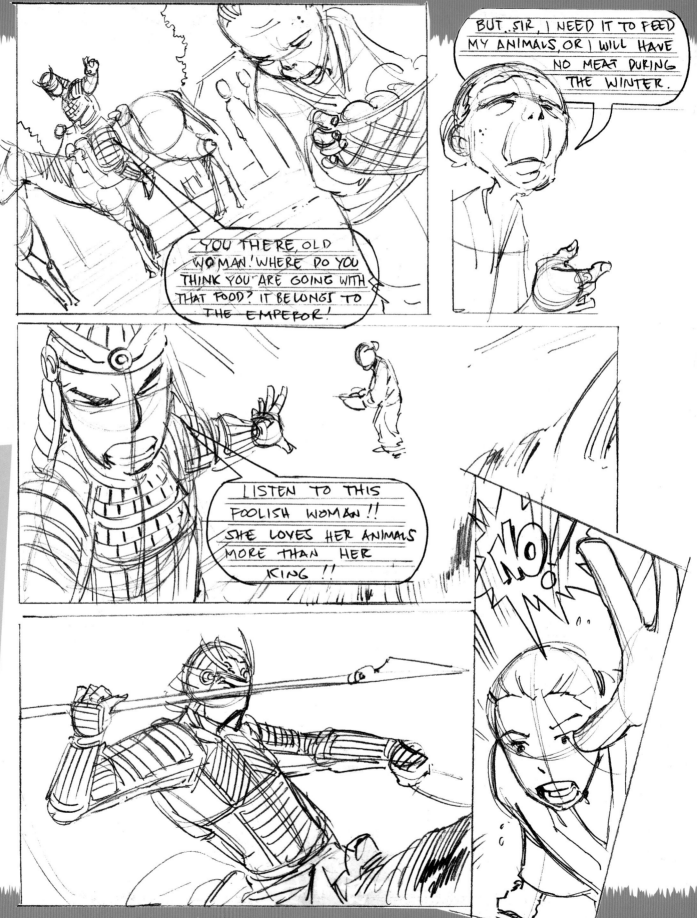

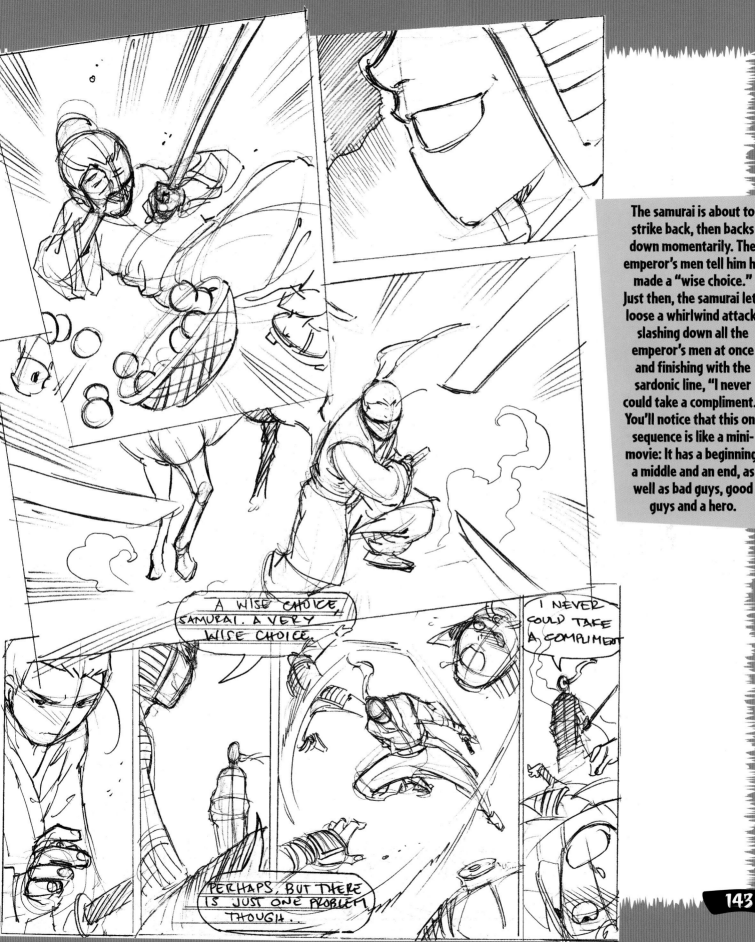

The samurai is about to strike back, then backs down momentarily. The emperor's men tell him he made a "wise choice." Just then, the samurai lets loose a whirlwind attack, slashing down all the emperor's men at once and finishing with the sardonic line, "I never could take a compliment." You'll notice that this one sequence is like a mini-movie: It has a beginning, a middle and an end, as well as bad guys, good guys and a hero.

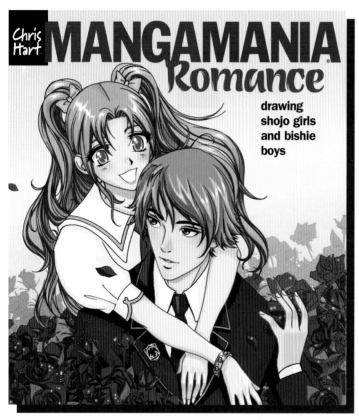